Interpreting
POLLOCK

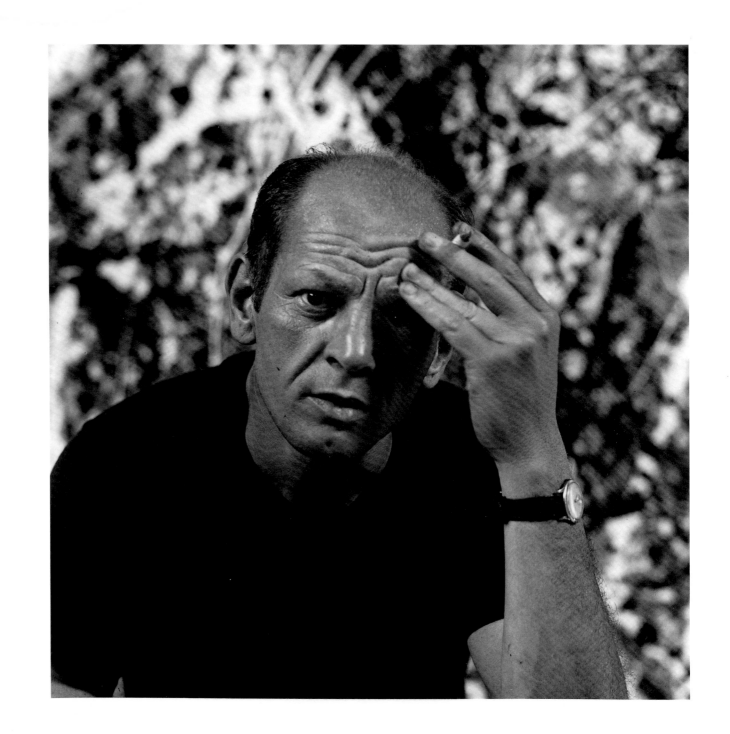

Interpreting
POLLOCK

Jeremy Lewison

Tate Gallery Publishing

I would like to acknowledge the assistance I have received in researching this book from my colleague Michela Parkin, who has responded to all my requests for help with enthusiasm, calm and assurance. Without her extraordinary persistence in tracking down obscure items in far-flung libraries the cause might have been lost. Sue Smith has also been very support-ive. The book has been designed and edited by Tate Gallery Publishing and in particular I would like to thank Celia Clear, Sarah Derry, Tim Holton and the design and production staff for their help and close co-operation, and Clarissa Little of the Exhibitions Department for her help with obtaining illustra-tions. I would also like to thank my wife, Caroline, and my children, Kate and Lexi, for their devoted support and consid-erable tolerance. The success of such projects tends to rely on those in the background and I am grateful to them all.

Jeremy Lewison

This book is published to coincide with the exhibition *Jackson Pollock* organised by the Museum of Modern Art, New York. The showing at the Tate Gallery, London is supported by *The Guardian* and an Anonymous Foundation and is in association with American Airlines.

front cover: **Reflection of the Big Dipper** 1947 (detail, fig.41)
frontispiece: **Pollock in Front of *One: Number 31, 1950*** 1950
(Photograph Hans Namuth © 1999 Hans Namuth Ltd)
back cover: **Summertime: Number 9A, 1948** 1948 (detail, fig.42)

Published by order of the Trustees of the Tate Gallery by
Tate Gallery Publishing Ltd
Millbank
London
SW1P 4RG

ISBN 1 85437 289 0

A catalogue record for this book is available from the British Library

Designed and typeset by Caroline Johnston
Printed in Great Britain by Balding + Mansell, Norwich

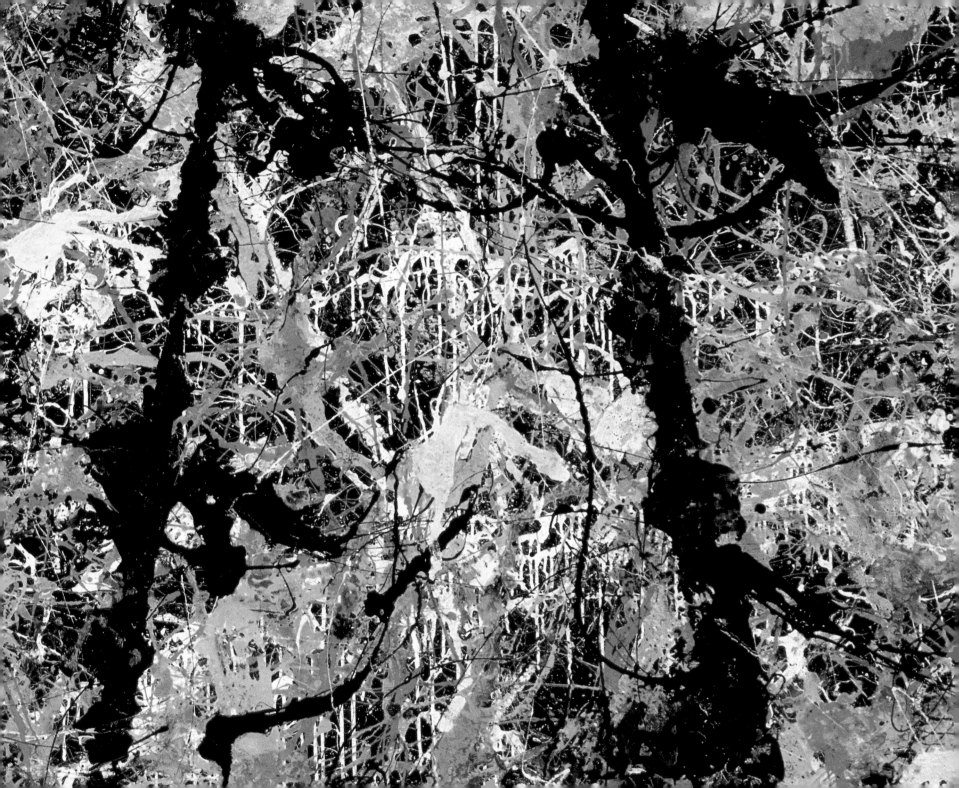

Introduction

When Peggy Guggenheim exhibited her collection in Venice in 1948, Jackson Pollock was virtually unknown in Europe. Only those who were attentive readers of *Horizon*, Cyril Connolly's literary journal, would have had an inkling of what they might have seen had they travelled to Venice, for within the covers of the October 1947 issue was the critic Clement Greenberg's article, 'The Present Prospects of American Painting and Sculpture'. Because of British post-war impoverishment few people made it to Venice, but the Scottish artist, Alan Davie, was amongst them. Davie saw Peggy Guggenheim's collection, which went on view in the otherwise empty Greek pavilion at the Biennale, and impressed though he was by her important Cubist, geometric abstract and Surrealist art, it was about Pollock that he enthused when he returned home. In Pollock he sensed a kindred spirit, 'a passionate interest in the art of primitive peoples' and a sense of 'liberation – a setting free of the natural spiritual flow within us'. Although Davie spread the word on his return to Britain few other artists were exposed to the work.

It was Greenberg who set the tone for the English media's response to Pollock when he stressed the violence of Pollock's art, its Americanness and its radical nature. By the time Pollock died in 1956 he was one of the best known artists in the world,

rivalled perhaps only by Picasso. Pollock became notorious thanks to an article in *Life* magazine, published in 1949 under the headline 'Is he the greatest living painter in the United States?' This was followed by a series of exhibitions mounted by the International Council of the Museum of Modern Art, New York, a film by Hans Namuth and a number of memorable photographs which seemed to accompany almost every major article written about him. Tales of drunken binges, wild-west origins, paintings executed with mindless speed and extracted from the unconscious created an image of the artist as shaman. Could he be taken seriously? The critics and those in powerful cultural positions in the 1950s were divided.

Being an American it was impossible to be a serious, innovative artist; at least so it was thought by a number of commentators at the time. In *Horizon* in 1945 Bertrand Russell characterised Americans as lacking 'respect for knowledge' and their country as boringly uniform. Georgina Dix satirised the typical urban American as a philistine with no interest in history, living a life of standardisation. These two articles were symptomatic of the legacy of Empire among the older generation in the aftermath of war. America, they argued, was culturally inferior to Europe. According to the poet Stephen Spender, writing in *Horizon* in 1949, America had good novelists, 'a living body of protest against the vulgarity, commercialisation, advertising, exploiting, which many of us think of as the most characteristic American qualities', but they had to resort to alcohol in 'an effort to restore contact with the dionysiac, the violent, the real, the unconscious level of experience'. The English view was that in America violence and alcoholism went hand in hand with creativity.

When Pollock was selected to be one of the official representatives in the American pavilion at the Venice Biennale in 1950, those English critics who felt it worthwhile commenting were severely patronising. David Sylvester, soon to become one of the most perceptive writers on Abstract Expressionism, was, in his own words, 'blinded by an old-fashioned anti-Americanism'. Pollock represented 'the seamier side of America – sentimentalism, hysteria, and an undirected and undisciplined exuberance'. When Greenberg, who had suggested Sylvester review the exhibition in the *Nation*, remonstrated with him in the following

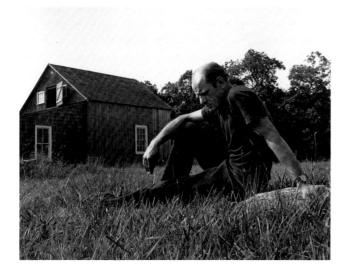

left **Blue Poles: Number 11, 1952** 1952 (detail of fig. 3)

right 1 Pollock outside his studio, The Springs, 1950
Photograph: Hans Namuth
© Hans Namuth Ltd

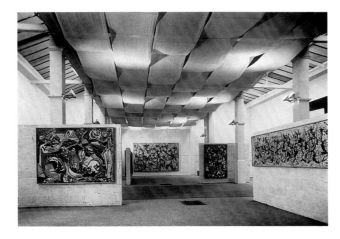

2 Photograph of the 1958
Jackson Pollock exhibition at the
Whitechapel Art Gallery
in London

issue, Sylvester went into overdrive. 'I disliked it because most of it represented a brand of American romanticism which, whether its outlet is painting, literature or theatre, I find repellent and contemptible, because it is incoherent, modernistic, mucoid, earnest and onanistic, because it gets hot and bothered over nothing and reminds me of Steig's drawing called "I can't express it".' Finally, he argued, painting superior to Pollock's could be found in the work of the European *informel* artists.

A similar attitude was to be found in France where the School of Paris and the dealers who represented it hoped to pick up where they had left off before the war. Much of the French press was controlled by the political parties or wore its political affiliations openly, and America, and anything American, was often a target for attack. Far from acknowledging the new look of American art in 1955, when it was shown in *Cinquante ans d'art aux Etats Unis*, they claimed that since most of the generation of Abstract Expressionists were of European origin their art was essentially European. In contrast to the works of Andrew Wyeth or Ben Shahn there seemed to be nothing distinctively 'American' about it, but, rather, it had a strong relation to European Surrealism. Hegemony was at stake and the power of Paris was on the wane.

There was no accounting, however, for a European public which was keen on anything and everything American, or for

a younger generation of artists who felt stifled by the grip of Picasso and Braque or the neo-romantic, nationalistic art of their homelands. Whether they had been subjected to a fascist blackout, as in Italy or occupied France, or isolated from contact overseas as in Britain, the end of the war meant a breaking down of boundaries and the rise of new aspirations. The American dream entered the lives of everyone who went to the cinema to watch westerns, gangster movies, *film noir* and Hollywood epics. Visions of a consumer society in a land of plenty, where life on the street was bright and lively, not austere and depressing, helped to create a climate of welcome for the products of America, including its art. As the British artist Robyn Denny has stated: 'Europe was exhausted and wound down. Life in London was grey and austere, its art world more than ever prone to compromise and instrospection. I felt that the whole culture was flawed and frozen into fixed attitudes of expression and our art to have become shallow and self-indulgent. Thus the shows of post-war American art seen in London during the 'fifties were a kind of revelation asserting a future for art and, as in other fields of cultural endeavour at the time, the new world was taking the lead.' So when Pollock's paintings arrived in force in the mid-1950s his exhibitions were greeted with acclaim. So eager was the art world to gain information about Pollock that when Bryan Robertson, director of the Whitechapel Art Gallery, gave a talk about his work at the headquarters of the Arts Council, they queued around the block to be admitted. The BBC, always a good supporter of avant-garde art in those days, broadcast a lecture by Professor Meyer Schapiro and screened Hans Namuth's film on Pollock as part of the *Monitor* series. Artists greeted Pollock's work as an example of liberation: liberation from outmoded studio practices, liberation from their teachers and liberation from a limited European horizon. In mainland Europe liberation had wider associations still: liberation from oppression, freedom from fascism and freedom to determine individual destiny.

From now on the place of pilgrimage was New York, not Paris. The older generation might continue to make disparaging remarks about America – witness Herbert Read's letter to Howard Newby of the BBC in 1951 where he wrote: 'This is my fourth visit to America, so I am no longer excited by sky-

scrapers, American women or even American automobiles. The enduring satisfactions are American plumbing, unlimited supplies of orange juice and telephone operators ... The new horror is the undergraduate in tight jeans with "crew-cropped" head and ape-like slouch. Thousands of them identical' – but for many young artists New York was Mecca, and everything American, particularly the skyscrapers and the automobiles (and even the women), was to be worshipped. For Denny, 'Europe and the old world seemed to be abandoning in its art the attributes of thrust, inventiveness and risk. Hence new developments in American painting, and especially the works of Jackson Pollock, were a timely affirmation that the bold heart of art was still alive and in its rightful place at the centre of life.' For the artist Bridget Riley, who did not imbibe the American dream so completely, the 1956 show represented 'such a big shift. The scale and freshness of Abstract Expressionism did not look like anything one knew and I found it surprising and stimulating. It made me very curious and I wanted to try to understand what they were doing and why. I remember thinking that obviously art is not dead after all. First there had been the huge interruption of the war, and during that time and for a while afterwards, the energy of many artists was channelled into art education. So there was a wide gap for a young artist between what happened on the Continent before the war and the arrival of Abstract Expressionism; for us it seemed that there was only William Coldstream in between. Abstract Expressionism was an explosion of vitality and you felt that the real, what we now call the "cutting edge" of art, had not stopped before the Second World War but was still alive. We had a present as well as a past.'

Even the critics were not immune to the impact of seeing Pollock in depth and, after hostile beginnings, they came around to welcoming the exuberance, scale and invention of his art. In Italy, where the Communist party was one of the strongest and instructed its affiliates to condemn abstraction, Marco Venturoli, the critic of the Communist *Paese Sera*, underwent a Damascene conversion and confessed that his wholesale dismissal of abstract art was no longer tenable. Even Renato Guttuso, the Communist-affiliated social realist artist, wrote favourably about Pollock.

A school of gestural abstraction was born overnight as students at art school throughout Europe sought to emulate Pollock, but his influence was more far reaching than simple emulation. Pollock's example was regarded by artists as an excuse to do anything they liked: ride bicycles over wet paintings, make performance art, use any materials at hand to make any objects they liked. There was no need to make works with overt meaning; the meaning resided in the making and the materials of the work. Namuth's photographs and Harold Rosenberg's concept of 'action painting' – where the act of making painting was more important than the finished work – were responsible for that. The American artist Allan Kaprow could announce in the pages of *Artnews* in October 1958 that Pollock had 'destroyed painting', leaving the artist 'at the point where we must become preoccupied with and even dazzled by the space and objects of our everyday life, either our bodies, clothes, rooms, or, if need be, the vastness of Forty-Second Street. Not satisfied with the *suggestion* through paint of our other senses, we shall utilize the specific substances of sight, sound, movements, people, odor, touch. Objects of every sort are materials for the new art: paint, chairs, food, electric and neon lights, smoke, water, old socks, a dog, movies, a thousand other things which will be discovered by the present generation of artists.' Pollock was a watershed, standing between the first and second halves of the century, providing continuity between the past – Picasso, Miró and Surrealism – and the future – performance art, conceptual art, minimal art, *arte povera*, *support-surface*, gestural abstraction, painterly Pop art and even Op art.

The general response in America was fairly similar to the response in Europe. Pollock had a mixed reception and was not well collected, although he had a small, faithful band of supporters. He was commercially unsuccessful until late in his short life and not well patronised by museums. Indeed it was only the demands of European museum and gallery directors for a Pollock exhibition, especially Arnold Rüdlinger in Basel and Bryan Robertson in London, which encouraged the Museum of Modern Art to take the plunge and organise a retrospective in 1956. It was substantially this show that went on to São Paolo and then on a European tour. And when the 1958 exhibition *The New American Painting* was received so successfully in Europe, it was hastily included in the Modern's pro-

gramme and billed as the 'new American Painting as shown in eight European countries'. America, it seemed, required European endorsement of the quality of its culture.

After Pollock's death in 1956 his reputation really took off, and demand for his work rose rapidly. There was a limited number of works and collectors began to look for trophies. After having been declined by the Museum of Modern Art for $6,000 a short time before, *Autumn Rhythm* was purchased by the Metropolitan Museum of Art in New York in 1957 for $30,000. And when the Australian National Gallery acquired *Blue Poles* for $2,000,000 in 1973, it caused an international outcry and had a far-reaching effect on the future enactment of the gallery's acquisitions policy.

Much of what has been written about Pollock – and there has been an enormous amount – is a perpetuation of myth, and myths fuel the market. In the 1960s it was fashionable to talk about art from a formal point of view and the issue of content was redundant. In the 1970s, when the whole of New York seemed to be in psychoanalytic treatment, if the films of Woody Allen are reliable evidence, it was modish to look at the works from a Jungian standpoint. Content and symbolism were now all. Formal analysis was abandoned except by those who doggedly persisted in closing their eyes to the evidence amassed before them. In the 1980s art was seen as part of the social discourse and Pollock's paintings were treated as social documents. The discerning viewer, or perhaps the patient codebreaker, could read that exhibiting Pollock's work was part of a strategic plan to achieve American supremacy in the Cold War when his work was harnessed to propagandise the New York School at the expense of the dying School of Paris. Structuralism was also in the ascendant and art historians began to 'deconstruct' the 'codes' embedded in the works. In the 1990s Jung is back in, but in moderation; formal analysis is once again permissible and social history is now put at the service of explaining the work of art rather than the other way around.

The occasion of the Jackson Pollock retrospective at the Tate Gallery is a good moment to take stock, to reassess some of the views which have previously been published and perhaps to deconstruct some of the myths which cling like a limpet to this *artiste maudit*. This is not a chronological account of the life and work of Jackson Pollock but an attempt to come to grips with a number of different issues which will confront the questioning viewer. What was the role of the unconscious in the making of these paintings? What was the impact of Picasso on Pollock's art? How did the drip paintings relate to the world in which they were conceived? Why did Pollock abandon this manner of painting in 1951? Why was it so important to cloak Pollock in a myth of masculinity? In addressing these issues others have been ignored, but the number of publications on Pollock, and the number which this exhibition will doubtless stimulate, makes it safe to conclude that the information can or will be found elsewhere. For Jackson Pollock will continue to be regarded as the most innovative artist of his generation and, with Picasso and Matisse, one of the greatest of the twentieth century.

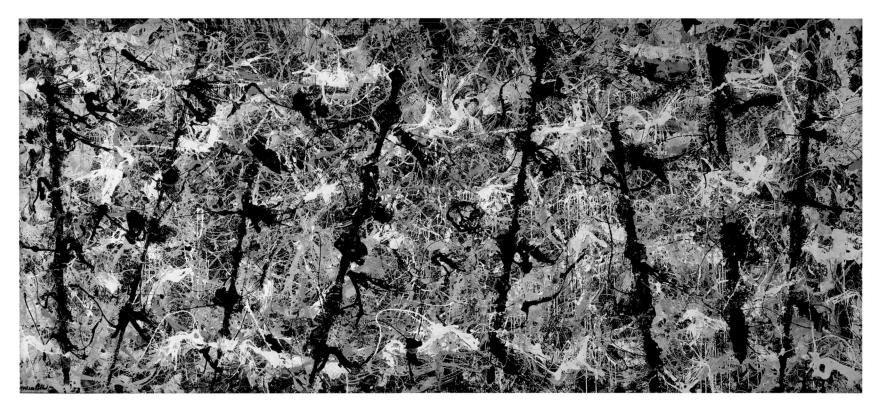

3 **Blue Poles: Number 11,
1952** 1952
Enamel and aluminium paint with
glass on canvas 210 × 486.8 cm
National Gallery of Australia,
Canberra

Picasso, Jung and the 'Primitive'

The first years of the Second World War were a period of American isolation. Contact with European culture was severed except for the fact that a number of European artists sought refuge from fascism in New York. As a land of freedom, America was perceived by a select band of critics and artists as having a responsibility to carry forward the torch of modernist culture while Paris was bound in the chains of fascist occupation. There was a growing sense that the time was now ripe to throw off the yoke of Paris, which for so long had hung around the necks of American artists, and to stand up for American art as an original, progressive expression of modern life. Exhibitions were mounted pitting American artists against Europeans – for example *American and French Paintings* selected by John Graham at the beginning of 1942 which included Pollock's *Birth* (c.1941) – while such critics as Edward Jewell, writing in the *New York Times* on 2 June 1941, could propose that 'If there is to be a new movement, it would not be too fantastic to conceive of its forming here'. Art of this Century, the gallery owned by Peggy Guggenheim, Pollock's first dealer, was to be 'a research lab for new ideas', where artists were hailed for their independent spirit and their courage to strike out into new territory. They were urged to make the best of their 'native sensibility', as James Johnson Sweeney put it in his introduction to the catalogue of Pollock's first one-man show in 1943. American art needed a cultural identity which would be robust and distinctive and express American ideals and characteristics during a period of world conflict. Above all it should express the power of the modern nation. As Clifton Fadiman put it in a broadcast discussion about 'Art and our Warring World', America had passed through the childhood of the pioneer period and was 'now ready to develop as a civilisation'. Military, diplomatic and cultural powers were to be hand-in-glove.

Given the impossibility of obtaining fresh stocks of European art during the war, except from the refugee artists, the market fed off American art. It strengthened as the war progressed, in spite of inflation, and where there had only been some forty galleries in New York at the beginning of the war, by 1946 there were 156, with a number of new collectors entering the field. According to the critic Aline Louchheim, writing in *Artnews* on 1 July 1944: 'Collectors want painting which seems alive to them, surcharged with energy, or excitement, or emotional connotations ... They don't want work which is stylised.' The taste was for something raw, not sophisticated, and this implied American rather than European. Such was American self-belief that by 1948 it was possible for the critic Clement Greenberg to assert that American art led the world in contrast to a tired and depleted France.

Pollock's paintings of the period 1940–5 showed no signs of overt nationalism as the work of some American artists did in this period, but they demonstrated a strong engagement with indigenous, so-called 'primitive', art and mythology. A number of artists regarded tribal art as a valid source for painting, much as had Picasso and his generation in the first decade of the century and the Surrealists from the 1920s onwards. Pollock and his contemporaries had not hit upon something particularly new, although they heralded it as a major component in their quest to make an art for their times. 'Primitive' art was held to be directly expressive of emotional states, unencumbered by a controlling consciousness, and was an expression of the irrational. For Pollock, Adolph Gottlieb, Mark Rothko and Barnett Newman the 'primitive' was associated with the experience of terror, violence, brutality and tragedy. By and large their view was not supported by anthropological studies but was a romantic interpretation conditioned by wartime experience.

'Primitivism' was an ambiguous concept. On the one hand fascism and Nazism were described in the vocabulary often applied to 'primitive' cultures, while on the other hand the primitive could stand for the spiritual and the wholesomely communal. It was regularly seen as a counter to modern day materialism, industrialisation and mechanisation. Thus 'primitive' culture was directly related to the brutality of present day life as well as suggestive of an innocent, utopian past (or indeed present given the continuing existence of 'primitive' tribes).

Whereas earlier European artists had shown an interest in 'primitive' art of widely varying cultures, with a particular emphasis on Africa, American artists declared an interest in the 'primitive' arts of America and appropriated it to the cause of demonstrating the strength of an indigenous, American culture. In the early 1940s Mexican, South American and in particular pre-Columbian art were the focus of particular attention while the art

The She-Wolf 1943
(detail of fig.11)

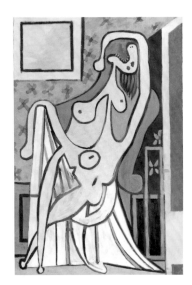

4 Pablo Picasso, *Large Nude in a Red Armchair* 1929
Oil on canvas 195 × 129 cm
Musée Picasso

5 **Birth** c.1941
Oil on canvas 116.4 × 55.1 cm
Tate Gallery

of the North American Indians, which had been in vogue throughout the 1930s, was the subject of an exhibition at the Museum of Modern Art in 1941. This exhibition, which was of particular interest to Pollock, attempted to harness North American indigenous culture to the history of American art and was part of a widespread recognition of the need to atone for the slaughter and repression of native American Indians in the previous century.

Evidence of the impact of North American Indian art on Pollock's painting is found in a number of works made around 1941–3, no more so than in such works as *Birth* (fig.5) and *The Moon-Woman Cuts the Circle* (fig.7). In the former, Pollock mixes images of masks taken from North American Indian sources with components borrowed from the paintings of Picasso. *Birth* has been compared with Picasso's *Girl Before a Mirror* (fig.6), shown in the 1939 Picasso retrospective at the Museum of Modern Art and by then part of its collection. However, the bent leg at the bottom of the painting may possibly have been 'lifted' from the *Demoiselles d'Avignon* (1907), also in the Museum of Modern Art's collection. One mask in particular is known to have been inspired by the reproduction of an Eskimo mask in John Graham's article on 'Primitive Art and Picasso', published in the *Magazine of Art* in 1937, of which Pollock had a copy. Graham, an important early influence on Pollock, proposed that 'primitive races and primitive genius have readier access to their unconscious mind than so-called civilized people.' An admirer of Jung, Graham believed in the collective unconscious as a source of power and creativity, a channel of access to the primordial and to information relevant to contemporary life. Picasso's paintings, he claimed, have 'the same ease of access to the unconscious as have primitive artists – plus a conscious intelligence.' Thus, according to Graham, Picasso mined the unconscious for truths about life and employed the conscious to control its expression. This was a model which Pollock was to adopt. In answer to a question about whether or not he admired the European refugee artists, Pollock, parroting Graham, remarked in an interview published in February 1944: 'I am particularly impressed with their concept of the source of art being the unconscious. This idea interests me more than these specific painters do, for the two artists I most admire, Picasso and Miró, are still abroad.'

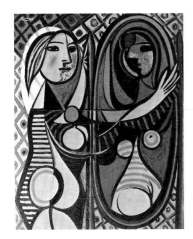

6 Pablo Picasso, *Girl Before a Mirror* 1932
Oil on canvas 162.3 × 130.2 cm
Museum of Modern Art, New York,
Gift of Mrs Simon Guggenheim

7 **The Moon-Woman
Cuts the Circle** *c.*1943
Oil on canvas 109.5 × 104 cm
Musée national d'art moderne, Centre
de Création Industrielle, Centre
Georges Pompidou, Paris. Donated by
Frank K. Lloyd, Paris, 1979

Pollock's interest in the mystical and the transcendent had been manifest from an early age. As a student at the Manual Arts High School in Los Angeles – he was brought up in the west – he was encouraged in this direction by Frederic John Schwankovsky, who introduced him to the writings of Krishnamurti and Rudolf Steiner, the founder of the Theosophical movement. With this background it was likely that he would be receptive to the ideas of Freud and Jung current in New York in the 1930s. While Pollock is alleged to have regarded Freud and Einstein as the two greatest thinkers of the twentieth century, it was to the Jungian branch of psychoanalysis that he submitted when he first went into treatment for alcoholism in 1937. This was followed in 1939 by psychotherapy sessions with Dr Joseph Henderson, himself an analysand of Jung in 1929 in Zurich, and then with Dr Violet Staub de Laszlo in 1940 when Henderson moved to San Francisco. As a student of Thomas Hart Benton, the American Regionalist painter, Pollock had been introduced to popular literature on psychology and to friends who had a particular interest in the workings of the mind. One such person was Helen Marot, a writer on psychology and its impact on industry who, like many Americans of this period, had replaced their strong Leftism with an interest in psychology when hopes of revolution, reform and social reconstruction were dashed at the end of the First World War. The final nail in the coffin of socialism came when Stalin signed a pact with Hitler on the eve of the Second World War. Marot's friend, Cary Baynes, at that time engaged in translating Jung's writings, introduced Pollock to Henderson. Thus Pollock was part of a network of people intimately engaged with the teachings of Jung and had access to conversation, if not texts, on Jungian concepts.

Towards the end of his life Pollock stated: 'We're all of us influenced by Freud, I guess. I've been a Jungian for a long time.' This statement, combined with the revelation that he took drawings to his sessions with Henderson, has provoked an extensive literature on the Jungian content of Pollock's paintings. The interpretations applied to Pollock's works have tended to reveal more about their authors than about Pollock, since they are essentially speculative. By all accounts Pollock was not a great reader and so is unlikely to have read any of Jung's writings, although he perhaps manifested some interest in the pub-lished papers of the Analytical Psychology Club in New York by virtue of possessing its list. He was able, however, to discuss rudimentary psychoanalytical concepts with his therapists, notably the psychic birth, death and rebirth cycle as well as the significance of the mandala. The drawings which he brought to his sessions do display an engagement with symbols, which Jung designated archetypes, although these sheets also display many motifs cribbed from Picasso. To what degree his interest stemmed from his therapy or was simply reinforced by it is open to question. Similarly the degree to which the symbols he employed had a definitive, prescribed meaning is questionable. While undoubtedly they had a personal significance or a number of different implications to him, whether these conformed to a Jungian interpretation is unknown. A number of other artists, including Rothko and Gottlieb, also made use of archetypes in their search for an expression of universal significance and neither of them was in analysis at the time. Indeed the notion of the archetype was common currency. Moreover, as Michael Leja has recently indicated, ideas about the unconscious permeated contemporary popular film and literature.

Jungian commentators have argued that *Birth* makes reference to the cycle of birth, death and rebirth; that the cylindrical form at the bottom right represents a birth canal, and that the circular mask-shape second from the top is surrounded by a plumed serpent. This, they claim, is an Aztec motif, a union of opposites where bird and snake signify high and low life respectively. Many of Pollock's paintings of this period are engaged with the union of opposites – male and female, sun and moon, full and crescent shapes – which, according to Elizabeth Langhorne, relates to Pollock's 'disturbed psychic life and, more specifically, to his efforts to resolve his negative anima complex and to achieve a union of psychological opposites, a harmony of self'. One of the problems of Langhorne's approach is that it depends upon accurate identification of symbols and motifs. She suggests that *Male and Female* (fig.10) consists of two figures, a male on the left and a female on the right. The 'figure on the left has a curling limp phallus that is red … and the one on the right has a yellow triangle in the pubic area, indicating that she is female.' She claims that Pollock adopted a colour coding of red for males and yellow for females. From this she extrapolates that

8 Pablo Picasso, *The Kiss* 1925
Oil on canvas 130.5 × 97.7 cm
Musée Picasso, Paris

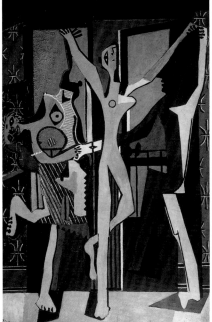

9 Pablo Picasso, *The Three Dancers* 1925
Oil on canvas 215 × 142 cm
Tate Gallery

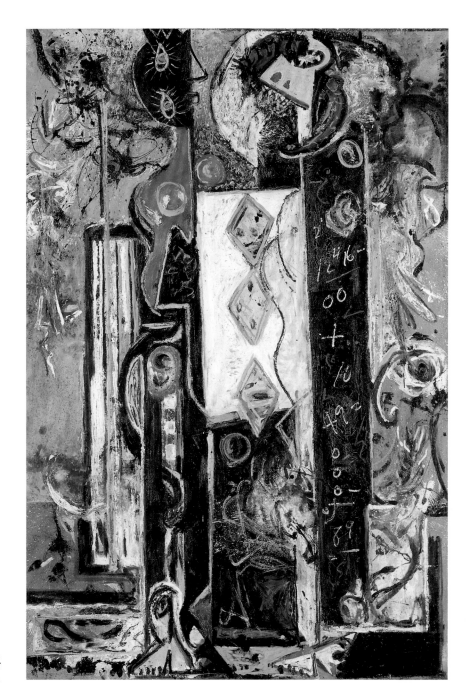

10 **Male and Female** *c.*1942
Oil on canvas 184.4 × 124.5 cm
Philadelphia Museum of Art. Gift of
Mr and Mrs H. Gates Lloyd

since both figures contain elements which are red and yellow the painting is about the union of opposites. She then states that the presence of diamond shapes in the centre of the painting suggests fertility and makes reference to 'the esoteric lore of alchemy'. However, one could easily make the case that the figure on the left is female and that on the right is male since the eyes of the left-hand figure have long, female lashes and her breast, indicated as a blue circle, is prominently displayed. Further, towards the bottom of the figure on the right is an explosion of whitish paint, suggestive of ejaculation. As for the diamonds, these occur not only in Picasso's *Girl Before a Mirror* as wallpaper pattern (as Langhorne indicates) but, perhaps more relevantly, in the centre of *The Kiss* (fig.8), where both the male and female wear diamond patterned costumes which merge together in the act of embrace (interestingly the male figure in *The Kiss* has the long eye lashes). As these two contradictory readings show, it is impossible accurately to identify the gender of the figures in this painting and this, rather than any sophisticated colour coding, might lead to the conclusion that the painting proposes the 'union of male and female', or the anima and animus. Or quite simply, since it was painted not long after Pollock and Lee Krasner began their relationship, it might celebrate their union.

Discussion of the concepts of anima and animus was almost bound to arise in Pollock's therapy sessions given that his analyst was Jungian, but Pollock would not have required a particularly sophisticated knowledge of psychoanalytical concepts to pictorialise them in this way. The problem with Langhorne's interpretation is that not only does it rely on Pollock having detailed knowledge of psychoanalytic theory but that the act of painting was a conscious act of self-analysis and transference. None of this is credible. The so-called plumed serpent motif in *Birth* clearly comes from the Eskimo mask illustrated in John Graham's article, while the alleged birth canal, an idea proposed by Judith Wolfe, is an echo of a motif found in one of Pollock's drawings of this period, where it might signify neck, tree stump or post. *Male and Female* has as its sources Picasso's *Three Dancers* (fig.9) and *The Kiss* rather than any psychoanalytical texts. The fact is that Pollock's paintings and the symbols within them are open to multiple interpretations and play on a

strong sense of ambiguity. If *Birth* is indeed about the act of birth it is difficult to identify with any certainty which is the infant form. What is certain, however, is that the demonic masks stacked vertically, as if on a totem pole, suggest an atmosphere of violence and threat and the archetypal vagina dentata. The painting has a hallucinatory quality suggestive of the depiction of the unconscious; that is to say that while it might or might not be the product of the unconscious, Pollock suggests that this is what the unconscious would look like if visualised.

Such a statement begs a question: what might signifiers of the unconscious look like for Pollock and by extension for the viewer? If one holds to a Jungian view, then archetypal symbols are the product of the collective unconscious. Since the forms of primitive art were taken to be archetypal there is a certain inevitability in Pollock's use of them. Thus forms which appear to have symbolic value, whether identifiable or not, are an index of the unconscious. In addition, an apparent randomness or chaos in the piling up of images might be intended to depict lack of rational control, and the thickly impastoed surface of many of his paintings could be a metaphor for psychic depth. In *Birth*, as in *The She-Wolf* (fig.11) and *Guardians of the Secret* (fig.16), Pollock covers up a substantial proportion of the surface with a last minute layer of paint (white in the case of *Birth* and blue-grey in the other two paintings) which suggests a veiling of the unconscious, or a momentary glimpse of it. Indeed the final image in a number of these paintings is only realised at a late stage, as though prompted by 'random' mark-making. The principal motif in *The She-Wolf* only finds form by virtue of the black-and-white contours applied late in the painting process. The form is pulled out of the morass of splashed, spotted and dripped marks similar in nature to those found in *Untitled [Overall Composition]* (c.1934–8) and which may derive from Pollock's experience of working in David Alfaro Siqueiros's 'Laboratory of Modern Techniques in Art' in 1936 (see p.12). The painting thus becomes a metaphor for the emergence of unconscious impulses into conscious thought. Other signifiers of the unconscious are the doodled ciphers in *Stenographic Figure* (fig.12), which some commentators have sought to interpret as having specific numerological significance, but which must surely only allude to numerology in the most general of ways. These forms

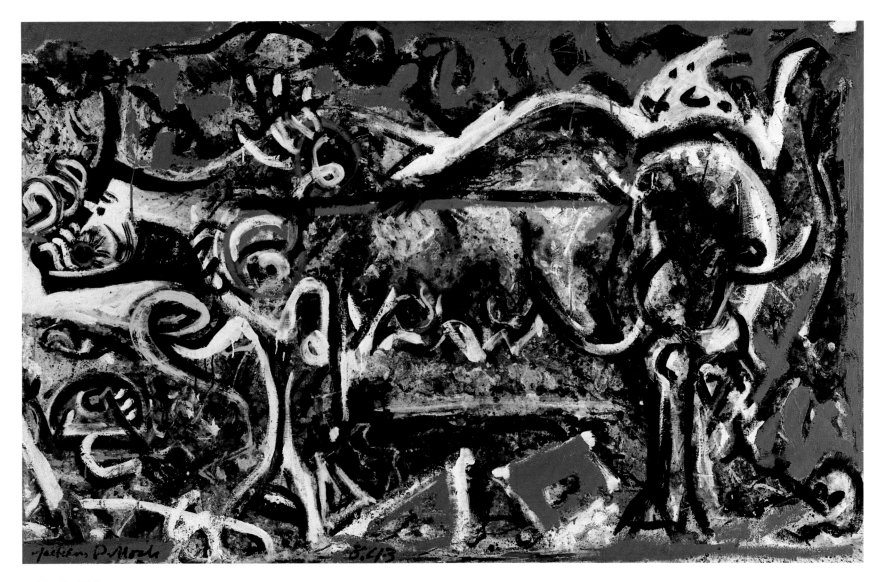

11 **The She-Wolf** 1943
Oil, gouache and plaster on canvas
106.4 × 170.2 cm
The Museum of Modern Art,
New York. Purchase

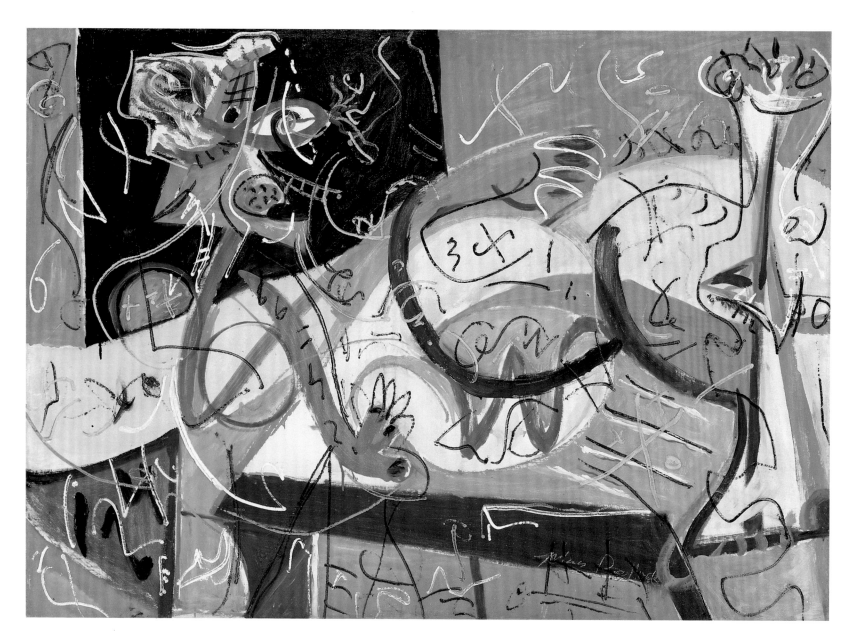

12 **Stenographic Figure** *c.*1942
Oil on linen 101.6 × 142.2 cm
The Museum of Modern Art. New York.
Mr and Mrs Walter Bareiss Fund

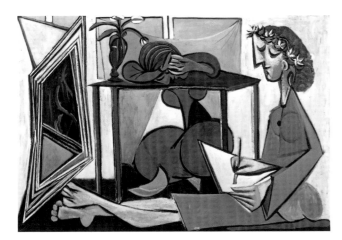

13 Pablo Picasso, *Interior with
a Girl Drawing* 1935
Oil on canvas 130 × 195 cm
Museum of Modern Art, New
York, Nelson A. Rockefeller
Bequest

14 **Untitled** *c.*1938–41
Pencil and colour pencil on
paper 35.9 × 28.3 cm
The Metropolitan Museum of
Art, New York. Gift of Lee
Krasner Pollock, 1982

far right 15 **Untitled
[Naked Man with Knife]**
*c.*1938–40
Oil on canvas 127 × 91.4 cm
Tate Gallery

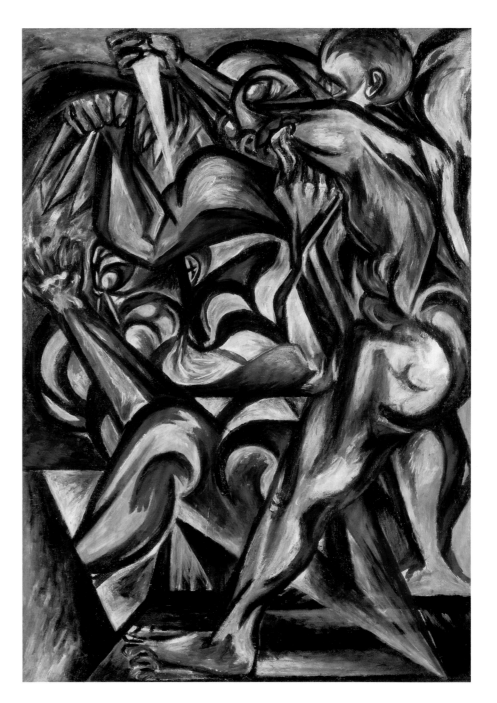

are those of an impregnable language, a code without meaning but which gains meaning by allusion to other codes. It is an automatic writing of the kind encouraged by John Graham in his book *System and Dialectics of Art* and which formed part of standard Surrealist game-playing. Similarly the numerals inscribed on *Male and Female*. They are, once again, indexical signs of the unconscious and Pollock's viewers would have understood them as such. The black markings on the central white panel in *Guardians of the Secret*, which if turned upside down become stick figures, might similarly be read as indexical marks. The fact that this white tablet, said to signify the unconscious, is covered with indecipherable markings when seen in the correct orientation, suggests the formlessness of the unconscious processes.

Leja has pointed out that ambiguity is an essential component of the Jungian concept of symbol and that the balance between legibility and obscurity Pollock achieves in his paintings shows evidence of an understanding of Jungian thought. However, ambiguity of symbol is found in many Surrealist paintings, not least in the work of Miró whom Pollock admired. Furthermore the fact that the title *Guardians of the Secret* may derive from the Theosophical concept of the 'Guardians of the Threshold', even though Jung applied this term to the animus and anima, makes an overtly Jungian reading less than certain given Pollock's earlier interest in Theosophy. In any case, a Freudian might interpret the white rectangle as a symbol of the unconscious and the sentinels, the eponymous guardians, as symbolic of the preconscious, that stage which acts as a guard and censor between the unconscious and the conscious.

Paintings like *Male and Female*, *Birth*, *Stenographic Figure*, *Pasiphaë* (c.1943), *The Moon-Woman Cuts the Circle* and *Head* (probably c.1940–1 rather than the normally given c.1938–41) all wear a look of the unconscious openly but they are in fact carefully worked and not spontaneous outpourings. Not only do they contain echoes of motifs to which Pollock returns repeatedly in drawings, but the fact that these paintings relate so closely in form and structure to specific precedents in the work of Picasso, regularly illustrated in *Cahiers d'Art* and exhibited in depth at the Museum of Modern Art in 1939, argues for a highly conscious manner of working and for perhaps a less specific

symbolic meaning than proposed by those who argue in favour of Jungian interpretations. *Untitled [Naked Man]* (fig.17), which is alleged to derive from paintings by Max Ernst, may be in fact a straightforward borrowing from Picasso's *Study for the Curtain for '4 juillet' by Romain Rolland* (fig.18), where a muscular male body with a bird's head strides forward carrying a hapless minotaur-harlequin figure. If this work was not available either in reproduction or in one of the New York galleries in the late 1930s, then it should be interpreted as a variant of the minotaur motif itself, which was well known to Pollock and understood to symbolise a mix of the unconscious, irrational and libidinous with the conscious, rational and restrained. The tripartite structure of *Male and Female* relates to Picasso's *Three Dancers*, while the crescent and full moon shapes, which may indeed signify male and female as well as the union of male and female, are both found frequently in Picasso's paintings. The stress on circular motifs as well as the exaggeratedly toothy masks in *Birth* correspond to Picasso's *Large Nude in a Red Armchair* (fig.4), where three circular forms suggest breasts and womb and a horseshoe head is lined with pointed teeth. *Stenographic Figure*, so often regarded as a reclining nude, is in fact a female seated at a table on which stands, possibly, a vase of flowers and corresponds closely with Picasso's *Interior with a Girl Drawing* (fig.13). Pollock elides the characteristics of Picasso's two females into a single figure and reverses the direction of the painting. If this reading is correct, it entirely invalidates the Jungian interpretation proposed by Langhorne which is based on reading the composition as a female 'Indian woman' on the left, representing the anima, and a male figure on the right. As for *Pasiphaë* (fig.20), this work has such a strong resemblance to Picasso's *L'Aubade* (fig.19), a painting depicting a reclining nude serenaded by a male guitarist, that any associations with the myth of the minotaur must be purely conjectural. Indeed it is well known that Pollock's own title for this was *Moby Dick*, but the painting was retitled *Pasiphaë* at the suggestion of James Johnson Sweeney. Whether or not Pollock could have known *L'Aubade* by this time has so far not been possible to establish – it was illustrated in the 1940–4 edition of *Cahiers d'Art*. Given that Pollock included *Pasiphaë* in his April 1944 exhibition, this was probably too late, but the resemblance is so great that there

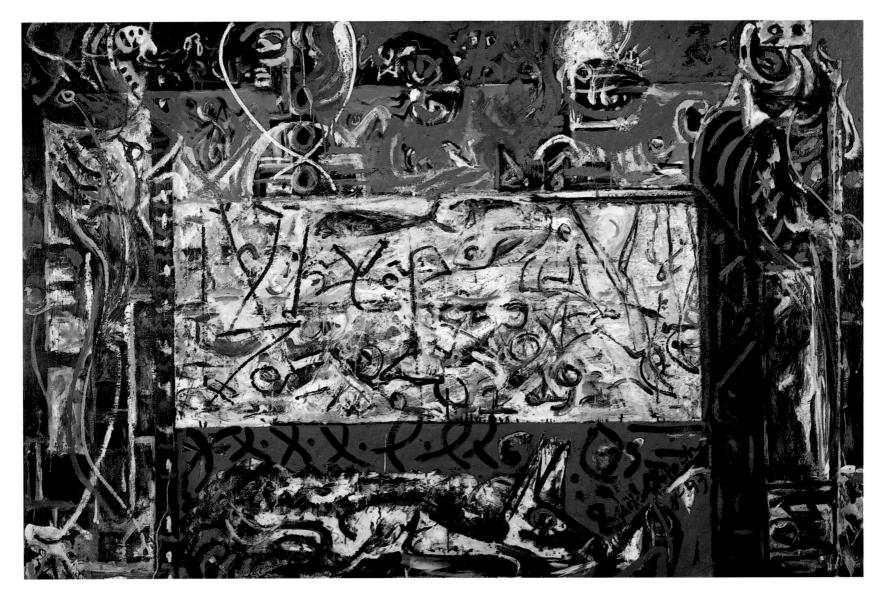

16 **Guardians of the Secret** 1943
Oil on canvas 122.9 × 191.5 cm
San Francisco Museum of Modern Art.
Albert M. Bender Collection

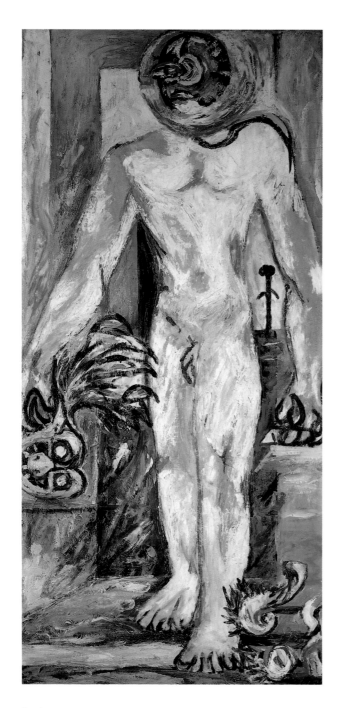

17 **Untitled [Naked Man]**
*c.*1934–41
Oil on plywood 127 × 60.9 cm
Private Collection, courtesy Robert
Miller Gallery

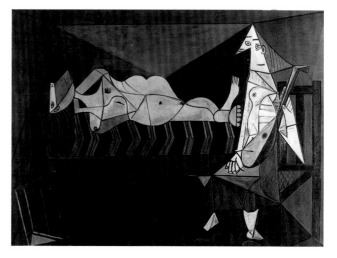

19 Pablo Picasso, *L'Aubade* 1942
Oil on canvas195 × 265.4 cm
Musée National d'Art Moderne, Centre
Georges Pompidou, Paris

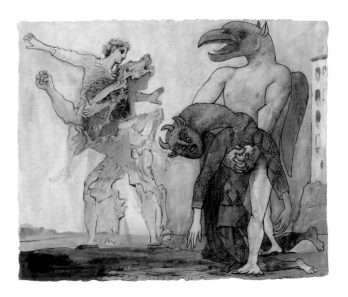

18 Pablo Picasso, *Study for the
Curtain for '14 juillet' by Romain
Rolland* 1936
Medium 44.5 × 54.5 cm
Musée Picasso, Paris

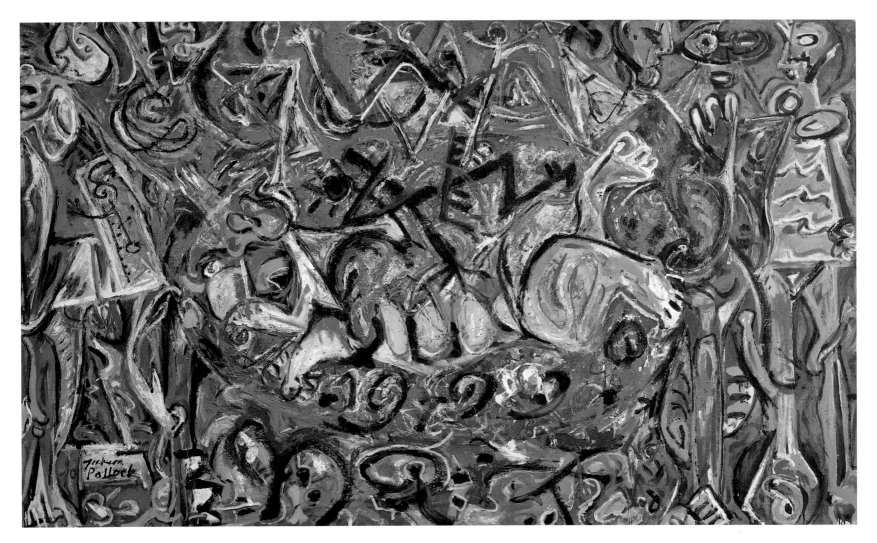

20 **Pasiphaë** *c.*1943
Oil on canvas 142.5 × 243.8 cm
The Metropolitan Museum of Art, New
York. Purchase, Rogers, Fletcher, and
Harris Brisbane Dick Funds and Joseph
Pulitzer Bequest, 1982

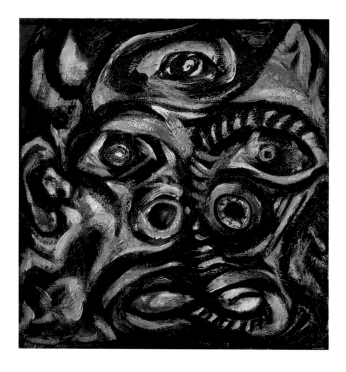

21 **Head** c.1940–1
Oil on canvas 40.6 × 40 cm
Sintra Museu de Arte Moderna,
Sintra. Berardo Collection

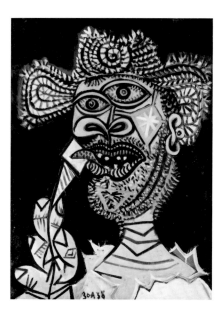

22 Pablo Picasso, *Man with a
Straw Hat and Ice Cream Cone* 1938
Oil on canvas 61 × 46 cm
Musée Picasso, Paris

remains a good possibility that he did. For example, the disposition of the feet in the Pollock mirrors the Picasso exactly. The emphasis on strong diagonals in the background of the Picasso is echoed, a little distantly, in *Pasiphaë*, while Picasso's guitarist has been transformed by Pollock into a sentinel on the right with another added on the left. If he did not know *L'Aubade* he would certainly have been familiar with *By the Sea* (1923) of which *L'Aubade* is in some senses a variant.

The Moon-Woman Cuts the Circle combines elements of North American Indian culture with reference to Picasso's *Girl Before a Mirror*. What Langhorne reads as an extended crescent arm with a diamond pattern may be either the reflection of the figure wearing an Indian headdress or a second figure. The diamond shapes, which Langhorne interprets as 'symbols of the union of opposites on the higher level of an individuated self', are a reprise of the diamond-shaped pattern in the background of Picasso's painting. Finally, Pollock's *Head*, which depicts the ubiquitous serpent, is strongly reminiscent of Picasso's *Man with an All-day Sucker* (1938) which he would have seen in the 1939 exhibition. This was one of a series of paintings (see fig.22) of bestial men in straw hats where the hats display exactly the same striped motif as Pollock employs on the serpent in *Head*. Even the serpent's head in Pollock's painting, located in the sternum, recalls the spiral motif in Picasso's hat, while the stripes above the mouth correspond to bristles in the Picasso. Picasso's painting may have evoked for Pollock a memory of the serpent image, perhaps initially unconsciously, but once the memory surfaced he adapted it to his own ends in a highly conscious manner. Moreover, as Leja has pointed out, snakes, birds and masked figures were to be found in the paintings of the Mexican painter Jose Clemente Orozco, whom Pollock admired. Orozco's influence is apparent in such earlier paintings as *The Flame* (fig.24), *Untitled [Naked Man with Knife]* (fig.15) and *Untitled [Composition with Ritual Scene]* (fig.23), although *Untitled [Naked Man with Knife]* also bears a strong resemblence to André Masson's *L'Enlèvement* of 1932. Pollock's achievement, it seems, was to adapt the images and vocabulary of Orozco and Picasso to represent the unconscious. It was not until he was able to dispense with such a conscious formulation of image that he could dig into the unconscious itself.

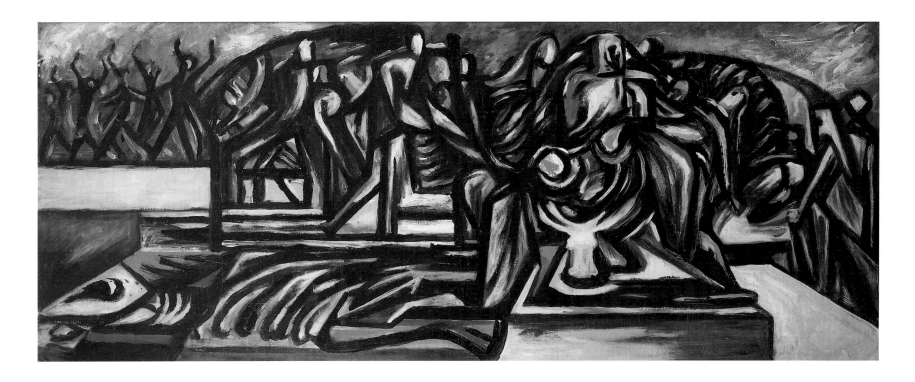

23 Untitled [Composition with Ritual Scene] *c.*1938–41
Oil on canvas mounted on masonite
48.3 × 121.9 cm
Courtesy Joan T. Washburn Gallery,
New York and the Pollock-Krasner
Foundation, Inc.

Much has been made of Pollock's poor relationship with his mother and his father's dysfunctional role as a parent. If ever there was a father figure for Pollock, however, it was Picasso and the dynamic between them was Oedipal. In his review of the 1939 Picasso retrospective, Edward Jewell stated that it was no longer possible to evade Picasso and that his work simply had to be taken into account by contemporary artists. Pollock's response to that exhibition was obsessive and, from what followed, it seemed he could not progress until he had consumed him. Lee Krasner, Pollock's wife, stated that 'there's no question that he admired Picasso and at the same time competed with him, wanted to go past him ... I remember one time I heard something fall and then Jackson yelling, "God damn it, that guy missed nothing!" I went to see what had happened. Jackson was staring, and on the floor, where he had thrown it, was a book of Picasso's work.' Pollock's therapist, Henderson, alleged that he tried to help Pollock be free of Picasso, as if to imply that Picas-

so acted as some kind of block to Pollock's self-expression.

Pollock's solution to this problem was gradual. While he worked through a range of Picasso paintings, borrowing images and structures liberally between 1940 and 1946, he gradually disguised or veiled them. Thus in such a painting as *The Key* (fig.26) he employs a Cubistic structure to control the apparent randomness of Kandinsky (*Night Fishing at Antibes*, 1939, by Picasso has been identified as a possible source for this painting). In fact his interest in Kandinsky, stimulated by working as an art handler (or preparator as they are known in America) at the Museum of Non-Objective Art in 1943 and by the Kandinsky exhibition held there in March 1945, became a tool for his release from Picasso's stranglehold. Pollock's first poured painting, *Untitled [Composition with Pouring I]* of 1943 (fig.27), bears a strong resemblance to Kandinsky's paintings of 1913–14 in terms of colour, abstractness and the use of black line to define structure, although such extensive use of poured paint more

24 **The Flame** *c.*1934–8
Oil on canvas, mounted on fibreboard
51.1 × 76.2 cm
The Museum of Modern Art,
New York. Enid A. Haupt Fund

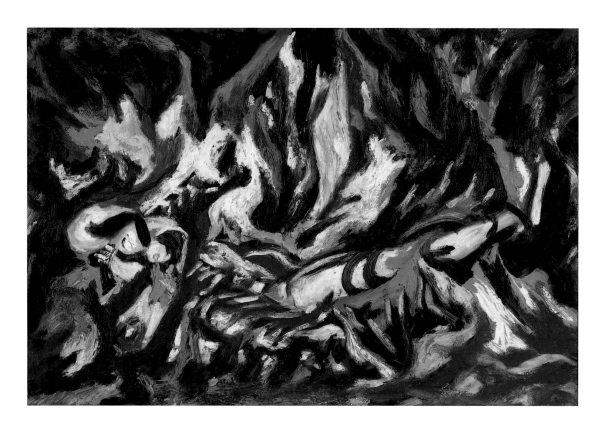

25 **Going West** *c.*1934–8
Oil on gesso on fibreboard
38.3 × 52.7 cm
National Museum of American Art,
Smithsonian Institution, Washington DC,
Gift of Thomas Hart Benton

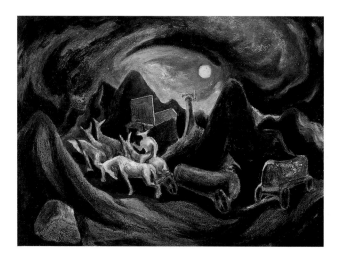

26 **The Key** (Accabonac
Creek Series) 1946
Oil on canvas 149.8 × 213.3 cm
The Art Institute of Chicago. Through
prior gift of Mr and Mrs Edward Morris

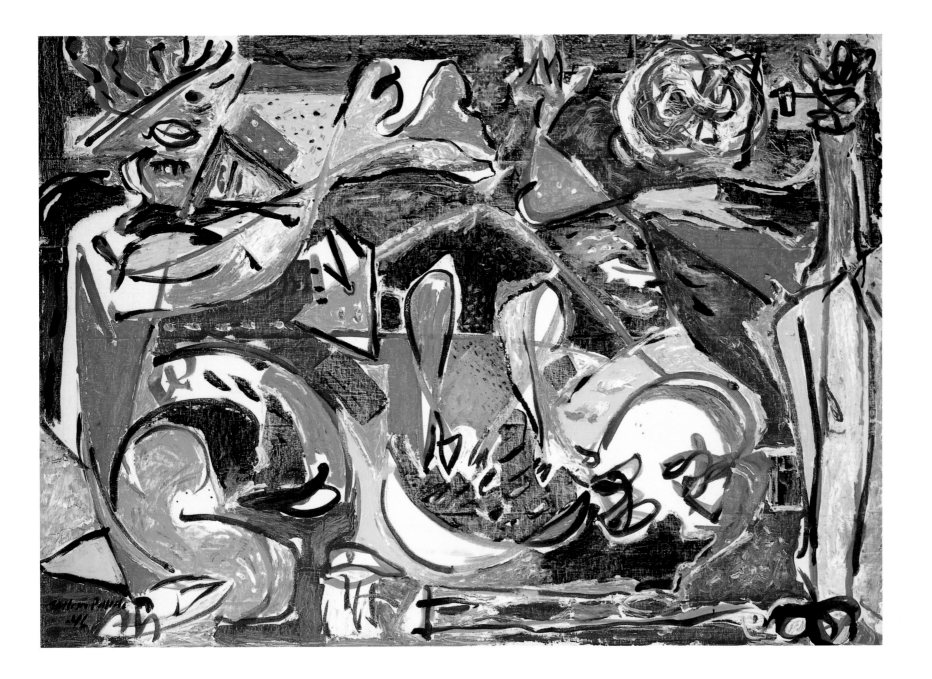

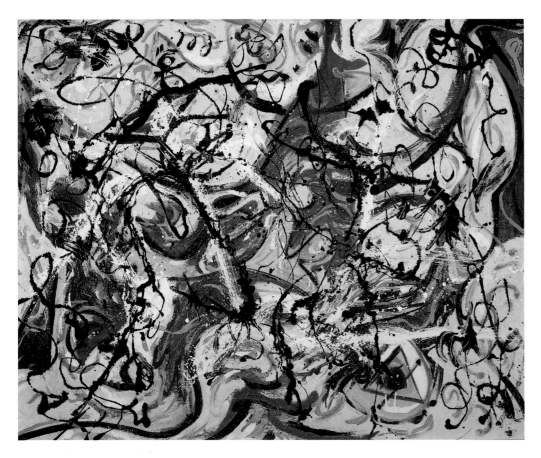

27 **Untitled [Composition with Pouring I]** 1943
Oil on canvas 90.8 × 113.6 cm
Private Collection

likely derived from his experience in Siqueiros's workshop, from his admiration for the work of André Masson or from the encouragement he received from Roberto Matta Echaurren to eliminate contact between brush and canvas. In this and paintings of subsequent years Pollock began to disguise the figure either within a Cubistic grid, as in *Gothic* (1944) or *Troubled Queen* (c.1945), or by literally covering it up with subsequent layers of paint.

Exactly what is depicted in *Gothic* (fig.28) is not immediately obvious. It is often regarded as a reprise of the theme of dancing figures found in the roughly contemporaneous *Mural* (fig.30), with Picasso's *Three Dancers* as a possible source. However close study of this work suggests that it might actually be a reworking of an earlier painting by Pollock, namely *Untitled (Woman)* (fig.29) in which a seated woman with splayed legs is surrounded by six figures. Head shapes similarly surround the central figure in *Gothic* and her legs also appear to be splayed. An alternative reading to this might be of a Madonna and Child (the fact that Pollock had made drawings after the old masters makes this perfectly plausible). However the work is interpreted, Pollock's intention is to disguise the image. Thus when he comes to paint such works as *Eyes in the Heat* (1946), *Galaxy* or *Full Fathom Five* (both 1947), he covers up the figure to release himself from the burden of a figuration, with which he is becoming increasingly uncomfortable, but still requires as a structure to work around. Picasso is only useful at this point as something to work against and ultimately destroy. The drip paintings may thus be construed in part as a way of making a bid for freedom from enslavement to Picasso. As Jonathan Weinberg has proposed, Pollock was negating the practice of 'precursors, as if trying to be that first artist who painted a picture entirely from himself'. The move towards the drip paintings was similar in impulse to the abandonment in the late 1930s of the models of Thomas Hart Benton and A.P. Ryder (see for example *Going West*, fig.25) in favour of the 'primitive': it represented a search for self and authenticity.

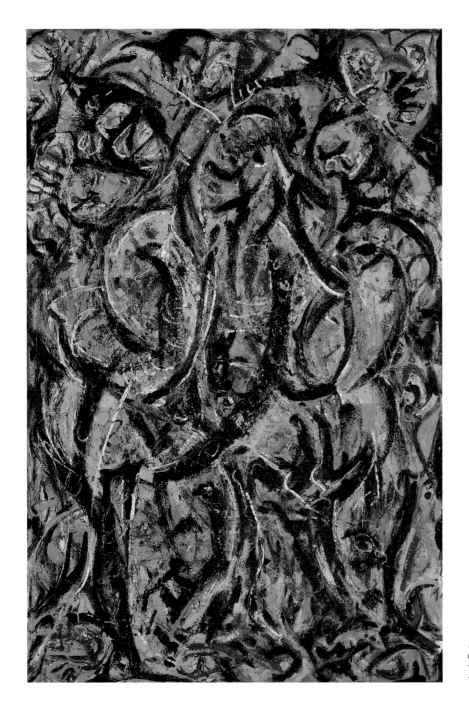

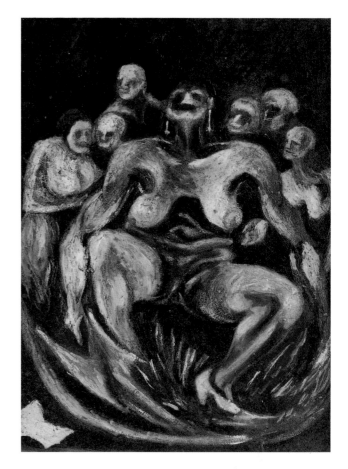

29 **Untitled (Woman)**
?c.1935–8
Oil on fibreboard
35.8 × 26.6 cm
Nagashima Museum,
Kagoshima City

28 **Gothic** 1944
Oil on canvas 215.5 × 142.1 cm
The Museum of Modern Art, New
York. Bequest of Lee Krasner

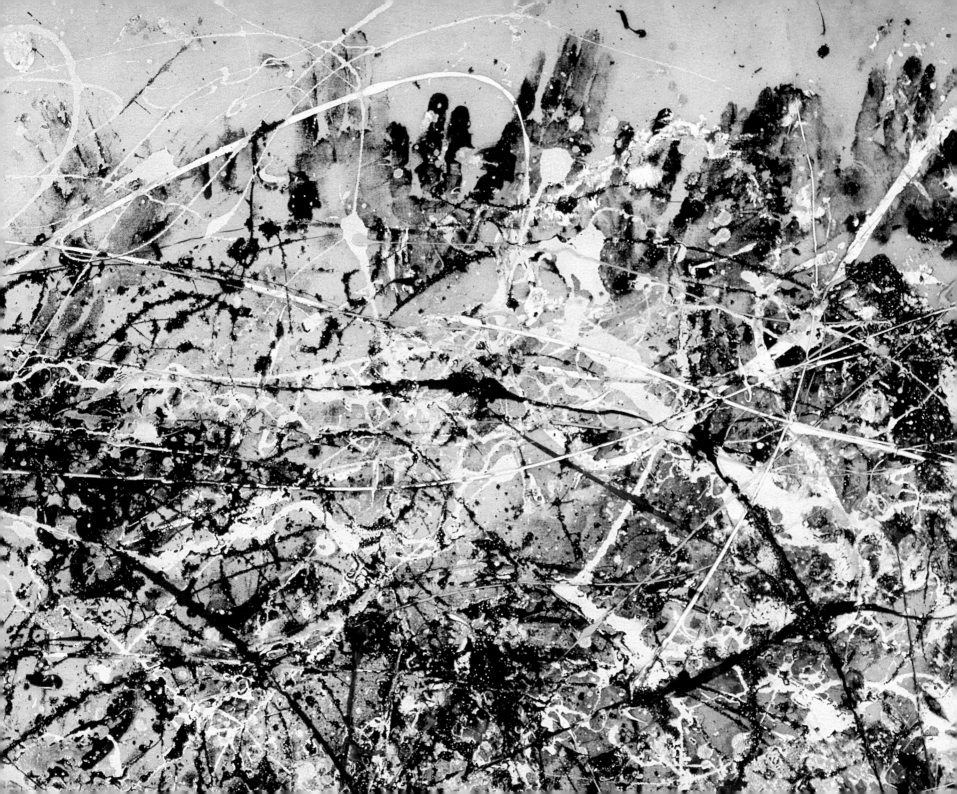

The Memory of Figure

In his public pronouncements Pollock has inferred two different propositions about his paintings. In a statement of 1950 explaining why he ceased to title his works by anything other than numbers he suggested that the drip paintings were completely abstract: 'I decided to stop adding to the confusion ... Abstract painting is abstract.' In 1956 he claimed that he had always been to some degree representational: 'I'm very representational some of the time, and a little all of the time.' While it was fashionable in the 1960s to regard Pollock's work as completely non-representational, in the 1990s the opposite is true. The truth is likely to lie somewhere between the two.

The key to the understanding of Pollock's so-called dripped paintings – between 1947 and 1950 Pollock did not confine himself to dripping and pouring paint but also applied it by squeezing tubes and brushing it on – lies in *Mural* (fig. 30), his first large-scale work, painted for Peggy Guggenheim's apartment. Pollock's previous experience of working on murals had been in the mural division of the Works Progress Administration with Thomas Hart Benton, whose figurative work had a social realist dimension. He could also not fail to have had in mind Picasso's *Guernica* (1937), a painting even larger than *Mural*, with a distinctly political programme, and the murals of Orozco who was also politically engaged.

Pollock had received the commission in the summer of 1943. Myth has it that he did not begin to work on it until at least December, or even possibly January 1944, although there is some evidence to suggest that he began it in the previous summer. Perhaps he was unable to decide on a subject or was daunted by the scale of the commission. If he had been considering painting a figurative composition in the manner of his most recent works he would have had to have looked at external models for help. While such paintings as *Untitled [Composition with Ritual Scene]* (fig. 23) had the look of a mural, based as it was on those of Orozco, it was small-scale. The motifs of Pollock's paintings of 1943 had been located in the centre of the canvas. These paintings relied upon the viewer being able to grasp the entire composition in one look. Even if there were figures or motifs on the edges, the stress was on the centre. In the entrance hall for which *Mural* was intended, it would have been impossible to get back far enough to take in the entire canvas at

once. Thus Pollock had to seek another solution. Furthermore, while he might have considered easel painting to be a place to explore private thoughts, his training might have told him that mural painting was suited to public statements. At this stage in his career, private thoughts were expressed by portentous and rather over-burdened symbols.

Given that Pollock was not in the habit of painting 'public' subjects – of political or social content – he appears to have opted for a decorative solution, in other words a painting with a repeat pattern. The painting consists of a mass of swirling marks in yellow, blue, red and white, brushed on thinly with feverish haste – it is alleged to have been made in a day and a night, although Carol Mancusi-Ungaro has recently established, by an analysis of the paint surface, that Pollock must have executed the work in successive, separate campaigns, since the paint would have smudged had he not done so. It appears to have little obvious sense of order, but is brought under control by a series of black forms resembling stick figures. These stick figures appear to walk from left to right in a manner reminiscent of a photograph of male nudes by Thomas Eakins which was illustrated in the *Magazine of Art* in January 1943 (fig. 31). The figures unify an otherwise disparate composition and permit the viewer to read it sequentially from left to right. As the viewer scans the painting, as he might in an entrance lobby, he essentially obtains the whole in the part. No section of the painting is privileged over any other; all are of equal weight. Along with the three poured works of 1943 this is, in effect, one of Pollock's first 'all-over' paintings.

The solution to working on a large scale was to be less overtly figurative than he had been, to define the figures in terms of strong black lines, rather than by areas of colour, and to use these black linear elements to unify and control the composition. Line does not act as a contour but is itself a form lying on the surface, pulling the viewer's gaze back from the depth suggested by the juxtaposition of colours. The black notations therefore have both a structural and a representational role. Stephen Polcari has associated the use of such markings in this and subsequent paintings by Pollock with Thomas Hart Benton's teachings. On the basis of his analysis of the old masters, Benton suggested that to make a horizontal composition it was

Number 1A, 1948 1948
(detail of fig. 43)

[33]

30 **Mural** 1943–4
(dated '1943')
Oil on canvas 243.2 × 603.2 cm
The University of Iowa Museum
of Art, Iowa City. Gift of Peggy
Guggenheim

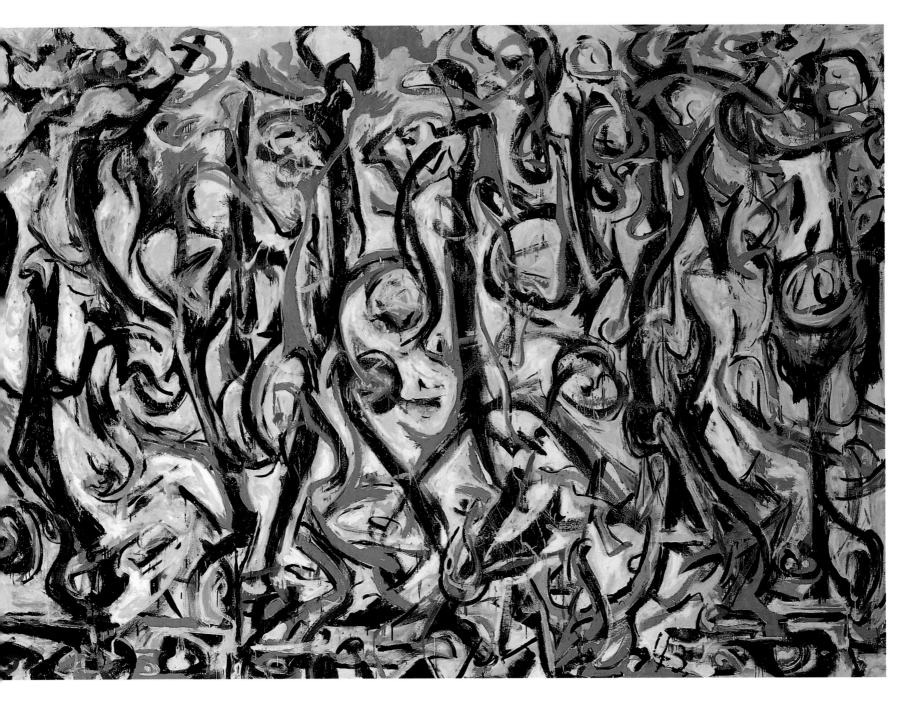

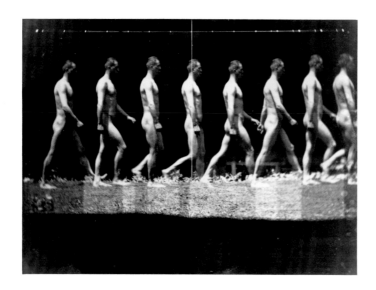

31 Thomas Eakins, Marey-wheel photograph of a man walking, 1885 Philadelphia Museum of Art, Gift of Charles Bregler

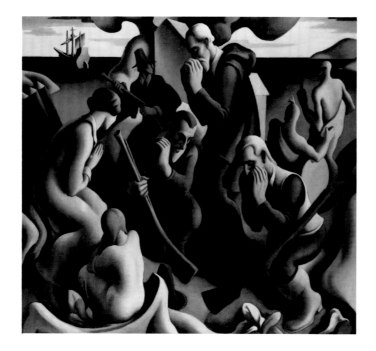

32 Thomas Hart Benton, *First Chapter: The American Historical Epic – Prayer* 1919–24 167.5 × 183 cm Nelson Atkins Museum of Art, Kansas City, Missouri. Bequest of the Artist

necessary to arrange the rhythmic sequences of marks and forms around a series of imaginary vertical poles. His thoughts about painting construction were illustrated in diagrams in a series of articles he published in *The Arts* in 1926–7. Pollock was intimate with Benton's teachings and there is no doubt that *Mural* has the cursive and serpentine rhythms of certain of Benton's paintings. But it would be wrong to think of the black markings in this painting as simply diagrammatic poles. Eakins may not have been the source for this composition, since stick figures have 'primitive' overtones and occur in several of Pollock's drawings, but the frieze-like composition so strongly resembles Eakins's photograph that it should not be discounted. In itself it would have provided a reminder of Benton's advice. The other important influence on this new departure must have been the work of Wassily Kandinsky. When Pollock worked at the Museum of Non-Objective Art in the summer of 1943 he would have noted the way Kandinsky punctuated and controlled paintings heavily laden with colours, seemingly abstractly applied, by the use of strong black lines and patches. Any suggestion that *Mural* owes something to Matisse is unlikely.

Although Pollock returned to painting overtly figurative subjects after completing *Mural*, they were nevertheless more fragmented and disguised than the paintings of 1943. In such works as *There Were Seven in Eight* (c.1945), *Totem Lesson 2* (fig.35) and *Troubled Queen* (c.1945) Pollock either 'veils the image' (his reported words), cancels or camouflages it by overpainting or placing it within a setting consonant with the motif. The figure is, in a sense, going underground. And this is indeed what appears to happen in Pollock's paintings of 1947–50.

Recent X-ray photographs of *Full Fathom Five* (fig.39) taken by the conservation department of the Museum of Modern Art, New York indicate a figure with a raised arm beneath the surface; *Eyes in the Heat* (fig.37) bears the vestiges of a figure rather like that in *Gothic*, and *Galaxy* (1947) is recognisably painted over a work titled *The Little King* (c.1946), which sits stylistically between *Totem Lesson 2* and *The Key* (fig.26). While Jonathan Weinberg has plausibly proposed that Pollock veiled the image to be free of the dominance of Picasso there were other operative factors. In the aftermath of war artists were looking for new ways to represent the age. From the optimism of the 1930s,

33 **Untitled** *c.*late 1937–9
Pencil and colour pencil on paper
45.7 × 30.5 cm
The Metropolitan Museum of Art, New
York. Purchase, anonymous gift, 1990

which had witnessed a strong belief in utopianism, social equality and social reform, the world had descended into a brutal war in which man appeared to be powerless in the face of mechanised forces of epic strength. As news of the death camps emerged and accounts of atomic explosions were made available, it seemed as though the world was spiralling out of control. There were deep misgivings about the role of science and technology in the post-war world, not least because its most recent manifestations had been so destructive. For some artists the irrational seemed more attractive than the rational, the chaotic replaced the ordered, the spiritual replaced the scientific. There was a crisis of confidence.

The representation and look of the unconscious, with its lack of clarity and order, was what such artists as Pollock aspired to. 'The modern artist', he stated in an interview in 1951, 'is working and expressing an inner world – in other words – expressing the energy, the motion, and other inner forces.' The use of the unconscious as a basis for art was a way of both avoiding and passing comment on the world, one of conscious disguise as well as unconscious revelation. Pollock continued: 'the modern artists have found new ways and new means of making statements. It seems to me that the modern painter cannot express this age, the airplane, the atom bomb, the radio, in the old forms of the Renaissance or of any other past culture. Each age finds its own technique.' In this rather banal statement Pollock asserts that through access to the unconscious he intended to paint about modern life. His paintings would be an expression of his reactions to that life: anxiety, helplessness and disillusionment. Krasner stated that Pollock 'experienced extremes of insecurity and confidence' and this was evidenced by his addiction to alcohol throughout his adult life (although he was relatively dry between 1948 and 1950). As Michael Leja has shown, these characteristics were also found in contemporary literature and film, particularly *film noir* that was so popular in this period.

By cancelling or obliterating his underpainted images, using an opaque but glistening aluminium paint applied with a brush, Pollock testifies not to any violent disposition, as is often claimed, but rather perhaps to a dissatisfaction with essentially pre-war methods of depicting the world and with his earlier efforts to depict the look of the unconscious. By leaving vestiges

34 Untitled *c.*1945
Black and colour ink,
gouache, pastel and wash
on paper 46.6 × 62.8 cm
Gecht Family Collection, Chicago

of the image in the paintings and drawings he appears to be depicting the preconscious. He does not make a complete break from figuration. It is still possible to make out the broad forms of *The Little King* in *Galaxy* and the grey paint in *Full Fathom Five* (fig.39) outlines a standing figure. Moreover, some of the objects incorporated into the latter seem to have been located at defining points. The key for example is placed where one might expect to find the genitals. Far from abandoning the figure it is held captive within the paint surface, within the complexity of the paint.

Leja has pointed out the disorientating spatial illusions encountered by the viewer as he contemplates the swirls of paint and the vortices of movement in such paintings as *Reflection of the Big Dipper* (fig.41), *Comet*, and *Phosphorescence* (fig.40) (all of 1947). Their titles affirm the infinite space of the sky or the ocean. Pollock appears to have been aiming at a new spatiality, one which extended beyond the confines of the canvas and suggested an infinite, indefinable breadth and depth. However, not too much importance should be attached to Pollock's titles, since they were mostly suggested to him by other people. Nevertheless, the spatial cues provided in the titles were taken up by many of the contemporary critics who invoked metaphors of web, labyrinth and vortex, as well as nature, to describe both the look and the effect of the paintings. Parker Tyler mixed the metaphors of web and labyrinth to express the insoluble nature of the paintings and a vision of entrapment. Another critic, Sam Hunter, likened the webs of black to 'agitated coils of barbed wire'. There was clearly something discomfiting about Pollock's new painting, which suggested man ensnared in the web or labyrinth of a force beyond his comprehension. As Leja points out, such metaphors were also found in *film noir* where male protagonists were portrayed as disorientated, subjected to external forces over which they had no control and, at times, in free fall. Pollock's paintings appeared to resonate with their times.

The web metaphor lay not just in the image depicted but also in the actual construction of the paintings. In *Phosphorescence,* the squeezes of white paint, which constitute the final layer, pin the painted surface in a criss-cross of lines. In *Summertime,* black and grey 'figures' are woven into the painting by thin skeins of black paint, while in *Number 1A, 1948* hand prints are

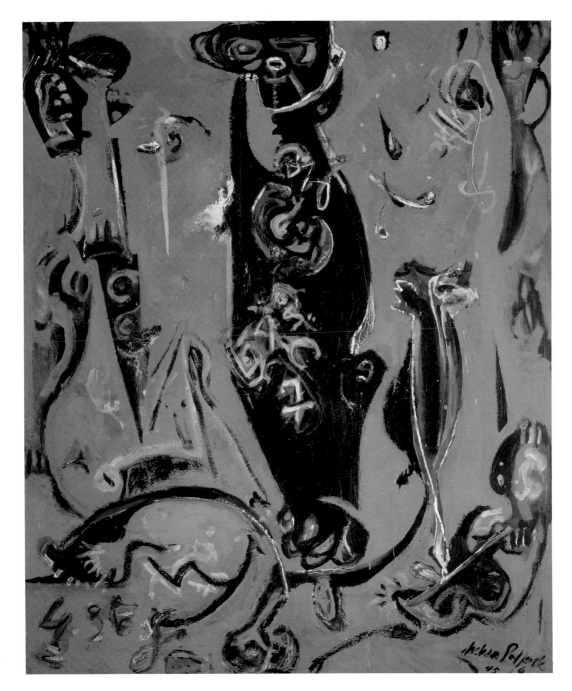

35 **Totem Lesson 2** 1945
Oil on canvas 182.8 × 152.4 cm
National Gallery of Australia, Canberra

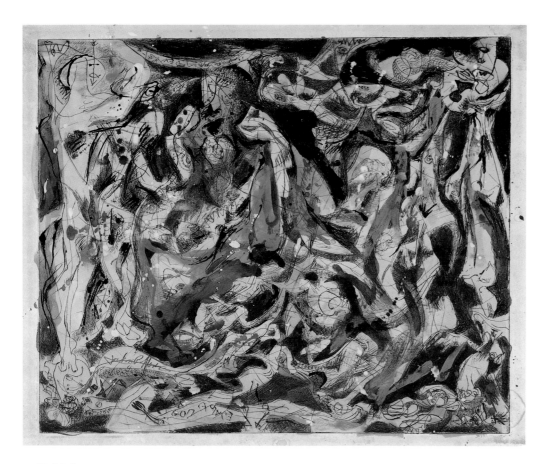

36 **Untitled** *c.*1945
Ink and gouache over engraving
and drypoint 44.9 × 54.3 cm
Collection The Guerrero Family

entwined in looping lines of paint. The continual entanglement of dribbled, poured and squeezed paint in Pollock's work evokes images of containment. Leja further points out that in those works where Pollock actually carves out forms, for example *Out of the Web* (fig.48), both containment and release are suggested.

The metaphor would not have been so potent, however, had the paintings, intentionally or unintentionally, not evoked the human figure without overtly representing it. Looking at the period 1947–50, it appears that Pollock used a number of different strategies. In the earliest works, such as *Full Fathom Five*, he not only consciously buries the figure but redraws it on the surface in the most rudimentary manner. In such works as *Summertime* (fig.42) he appears to have begun the painting as a calligraphic frieze of figures subsequently disguised in a web of lines. Similarly, *Number 32, 1950* (fig.47) contains veiled figures, notably on the right where a stick figure stands off the vertical, caught in a tangle of marks. In other paintings, for example *One: Number 31, 1950*, no figures are actually depicted but he uses black markings to control the field of colour in the way in which he did in *Mural*; that is, they function as might figures although they do not represent them.

In the monumental, 'classic' drip paintings of 1950 Pollock put down a series of figural markings in the initial application of paint. He then proceeded to obliterate the images, or weaken their presence, with actions of his arm and hand. However he may have had an instinctive memory of the first markings and these may have had an impact on the kinds of marks he made in the second stage. As he came to finish the painting it would have automatically borne a memory of the original markings (as underpainting at the very least) or he may have gone back in to impose order. He did that by making marks which, if not overtly suggestive of the figure, function in the same way, establishing a sense of space, however shallow or ambiguous. (In fact, because Pollock often left bare canvas and the drips and squeezes of paint have real body, a physical space is created.) Whichever method he employed, there is no actual figure necessarily visible. The marks Pollock made, which are influenced by his original urge to depict a figure or figural forms, in one way or another communicate that original intention. The painting holds a memory of the figure.

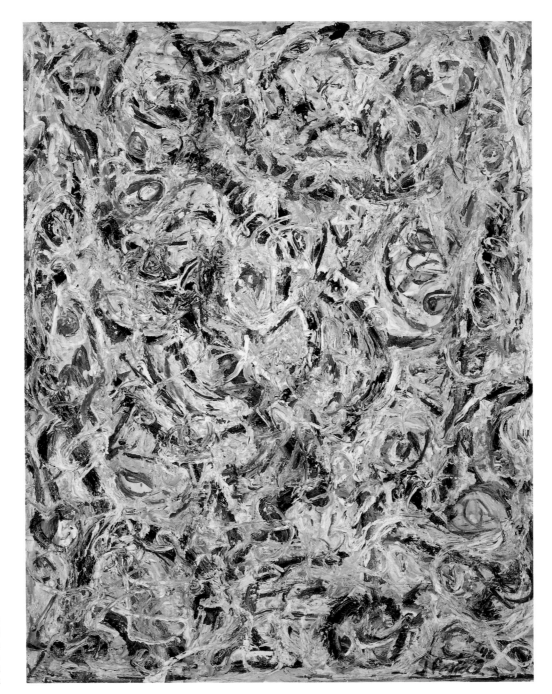

37 **Eyes in the Heat** (Sounds in
the Grass Series) 1946
Oil on canvas 137.2 × 109.2 cm
Peggy Guggenheim Collection, Venice.
The Soloman R. Guggenheim
Foundation, New York

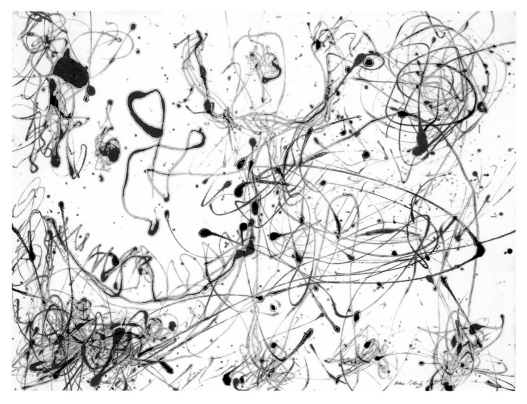

38 **Number 4, 1948:**
Gray and Red 1948
Oil and gesso on paper
57.4 × 78.4 cm
Estate of Frederick R. Weisman

In *One: Number 31, 1950* (fig.44) gestural black lines are dripped on top of the ground to create a figure-ground relationship, drawing the eye to the surface, creating rhythmic, dancing movement and bringing a storm of marks under control. These lines are read abstractly but they might also recall vestigial figures, since many of them are vertical or near vertical. They have been applied towards the end of the painting process and indicate either a conscious or instinctive last minute need to impose order and exert control, and perhaps a desire to inject a certain ambiguity into the reading of the painting. Hans Namuth's account is useful here. When Namuth arrived at the appointed time to photograph Pollock in action, Pollock disappointed him when he told him that he had just finished the painting he was working on. Namuth nevertheless asked to go into the studio and there he saw, on the floor, what was to become *One: Number 31, 1950*. 'Pollock looked at the painting. Then, unexpectedly, he picked up can and paintbrush and started to move around the canvas. It was as if he suddenly realised the painting was not finished. His movements, slow at first, gradually became faster and more dance-like as he flung black, white and rust-colored paint onto the canvas.' In contemplating the painting Pollock realised that it required more work, perhaps to make it denser, perhaps to order it, or perhaps to make more explicit the figural reference in a highly abstract image. In describing the final stages of the completion of *Autumn Rhythm*, a painting made immediately after *One: Number 31, 1950*, Robert Goodnough wrote in *Artnews* in May 1951: 'The design had become exceedingly complex and had to be brought to a state of complete organization.' If there was one accusation which Pollock vehemently rejected it was that his paintings were the product of random actions resulting in chaos. In response to an article in *Time* in 1950 with the headline 'Chaos, Damn It!' Pollock sent a telegram stating 'NO CHAOS DAMN IT.' If the veiling or obliteration of the figure is destructive, the final act is one of recuperation (of figure or control or both). As Leja states, Pollock's paintings enact the dramatic struggle between control and 'uncontrol' which modern man experienced in the post-war era. The energy of the painting resides partly in this transgressive state.

The need to exercise control over a painting process, allegedly

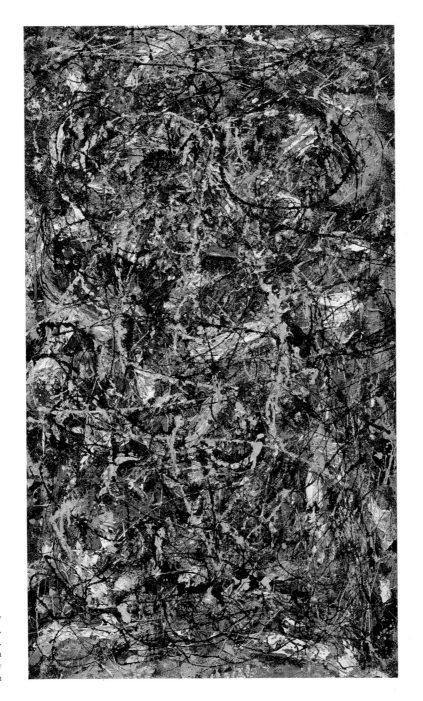

39 Full Fathom Five 1947
Oil on canvas with nails, tacks,
buttons, key, coins, cigarettes,
matches, etc 129.2 × 76.5 cm
The Museum of Modern Art, New
York. Gift of Miss Peggy Guggenheim

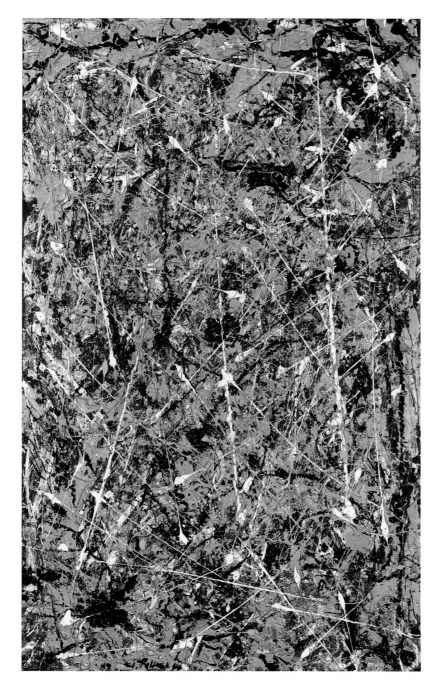

driven by the unconscious, that is to say, unpremeditated, gesture, and essentially to rescue it from randomness or disorganisation, may be the motive behind carving figure-like shapes out of the surface of *Out of the Web* (fig.48). The surface of the painting appears to be so choked with paint that Pollock may have felt the only solution was to remove sections of it in order to introduce some counterpoint. Alternatively, this action was a new method of incorporating figurative reference. Such smaller works as *Untitled (Cut-Out Figure)* and *Untitled (Shadows)* of the previous year were forerunners to this, suggesting that Pollock was looking for a new strategy and that the figure was in his thoughts. In fact the cut out figure hung around in his studio for quite some time before he determined how it would be used.

The fact that a number of Pollock's 1948–50 paintings do not appear to present figural remnants does not invalidate the argument that his paintings imply a sense of the figure. That there were occasions when he covered them up or disguised them indicates either that he needed such forms to work against or that, as in Cubist painting, their disguise was essential to the meaning of the work, or both. Further, if Pollock had adopted the same methods in all his drip paintings from 1948 onwards, in other words started from figural beginnings before obliterating them, and if such a reference was important to his intention in making paintings, it would be logical that towards the end of the painting process he would in some way or another, whether overtly, cautiously or obliquely, ensure that the figural reference became apparent. Either the figure is visibly buried beneath the web or the viewer himself becomes the figure referent. For Parker Tyler, the 'spectator does not project himself ... into these works; he recoils from them, but somehow does not leave their presence: he clings to them as though to life, as though to a wall on which he hangs with his eyes.' Tyler contends that Pollock's paintings do not permit the viewer either entry or exit but a distant, liberating, dizzying view of the universe and of life. For a brief moment the spectator can view it in all its complexity. He becomes the figure awed by the immensity of what he sees. Other commentators, however, argued the opposite; that Pollock's paintings made them feel enclosed or trapped in the picture space. Thomas Hess, for example, contended that 'seeing a Pollock is entering it; one feels like the statuettes inside

left 40 **Phosphorescence** 1947
Oil, enamel, and aluminium paint
on canvas 111.8 × 71.1 cm
Addison Gallery of American Art,
Phillips Academy, Andover,
Massachusetts. Gift of Mrs Peggy
Guggenheim

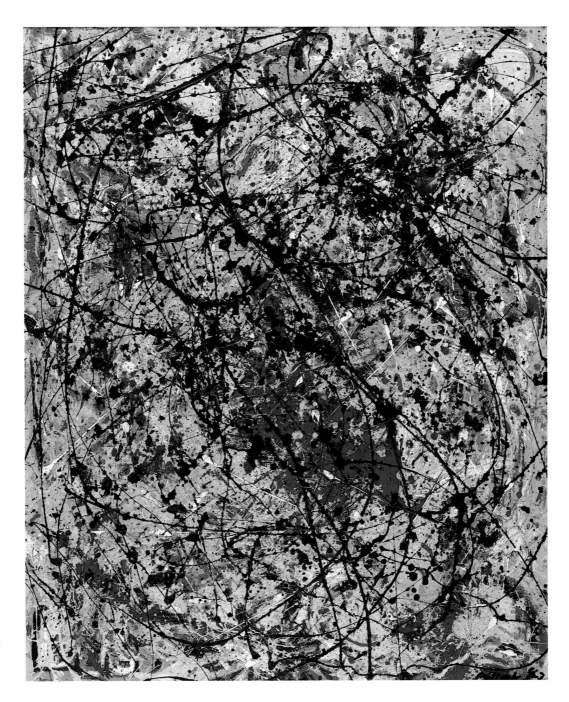

41 **Reflection of the Big
Dipper** 1947
Oil on canvas 111 × 92 cm
Stedelijk Museum, Amsterdam

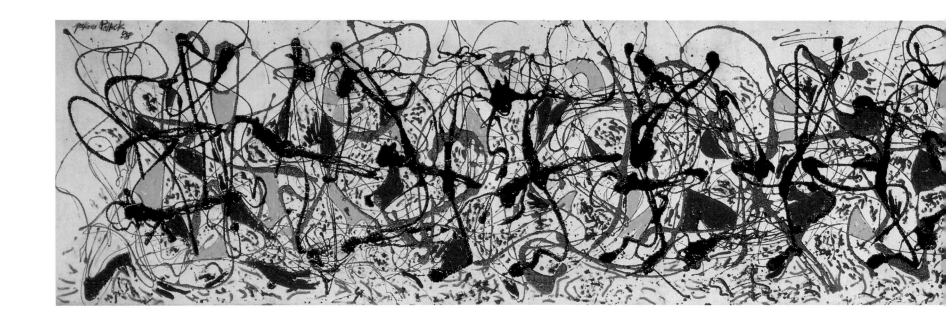

glass globes that, when shaken, are filled with snow flurries.' Either way, empathy is called for.

Pollock was not the only artist in this period to embed or disguise figures or figurative forms within his paintings. Of those with whose work he would have been familiar, Jean Dubuffet, to whom Clement Greenberg favourably compared Pollock, scratched figures into the paint surface of his landscapes as though they were inextricably linked to the land. Willem de Kooning, in his black paintings of 1947–9, left only traces of naturalistic form. Arshile Gorky, too, had developed from being an overtly figurative artist, highly influenced by Picasso and Miró, to suggest the human figure through the use of biomorphic imagery. Finally, Mark Rothko's *Multiform* paintings also developed out of naturalistic and then biomorphic forms. Thus the fact that Pollock did not completely abandon reference to the human condition is consistent with the work of other painters of this era.

Pollock's interest in expressing human presence in his paintings must surely explain the emphatic placing of handprints on

Number 1A, 1948 (see p.32) and *Lavender Mist: Number 1, 1950*. In *The Optical Unconscious*, Rosalind Krauss argues that the handprint is a signifier of absence; like graffiti it is a sign of an act which has taken place, a mark which has been left behind. While this is undoubtedly correct it does not negate the idea that the inclusion of handprints is intended to signify one-time presence. The palm prints face the viewer, appearing to be trapped behind the web of lines, pressing against the surface of the picture plane as though it were a sheet of glass. The handprint is a sign of self-revelation. In an article by Dr Lotte Wolff, titled 'Les Révélations psychiques de la main', published in *Minotaure* in the winter of 1935, the handprints of famous people were illustrated and analysed as an index of personality. Pollock may have been aware of this article or at least noticed the impressive reproduction of the handprints, since he perused *Minotaure* for Picasso's paintings and drawings (a copy of a 1933 issue was in his library when it finally came to be catalogued between 1963 and 1968, a fire having already destroyed a large number of periodicals). But even if he had not seen this

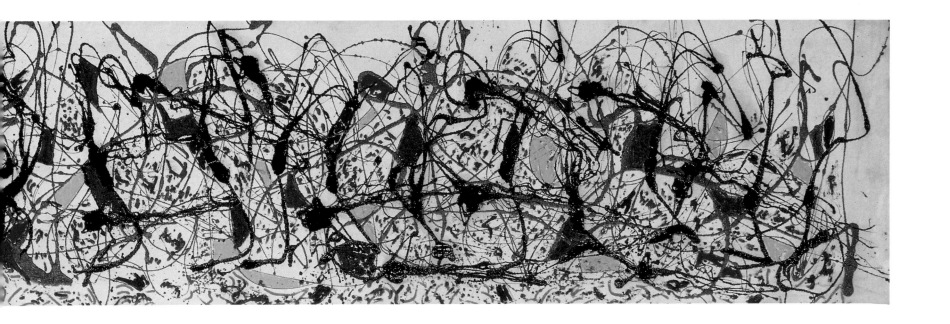

article, he must surely have regarded his handprint as an expression of self and an allusion to the body. The application of handprints was a fully conscious act, since to place them on the canvas he had either to lift it off the floor to the vertical, (the position in which he made 'conscious' decisions about it), or, while it was horizontal lie down on the canvas or more likely press down on it from the side or from the top. They certainly did not arise out of an impetuous slapping action as some critics suggested in the 1950s.

Handprints not only evoked sometime human presence but may also have suggested a connection to cave painting, and in particular those in Pech Merle in France where handprints are found on a wall. A form suggestive of the head of an antlered animal, drawn in outline at the top left of *Number 1A, 1948* (fig.40), lends credibility to the cave painting analogy. The handprint is evidence of the first human mark, of the first artist, the man or woman who makes the first visual expression. In some senses, Pollock's paintings of the period 1947–50, which are painted on the floor rather than on the wall, are an attempt to get back to the origins of painting, the primal statement, the drawing in the mud. John Berger, in a review of the Pollock retrospective at the Whitechapel Art Gallery in 1958, detected this primal urge: 'Imagine a man brought up from birth in a white cell so that he has never seen anything except the growth of his own body. And then imagine that suddenly he is given some sticks and bright paints. If he were a man with an innate sense of balance and colour harmony, he would, then, I think, cover the white walls of his cell as Pollock has painted his canvases. He would want to express his ideas and feelings about growth, time, energy, death, but he would lack any vocabulary of seen or remembered visual images with which to do so. He would have nothing more than the gestures he could discover through the act of applying his coloured marks to his white walls.' Berger depicts the *tabula rasa* to which Pollock appears to have aspired; a painting in which no vocabulary of seen or remembered images (principally Picasso) is detectable. In *Formless: A User's Guide* Rosalind Krauss, invoking the writings of Georges Bataille, suggests that by painting on the floor Pollock

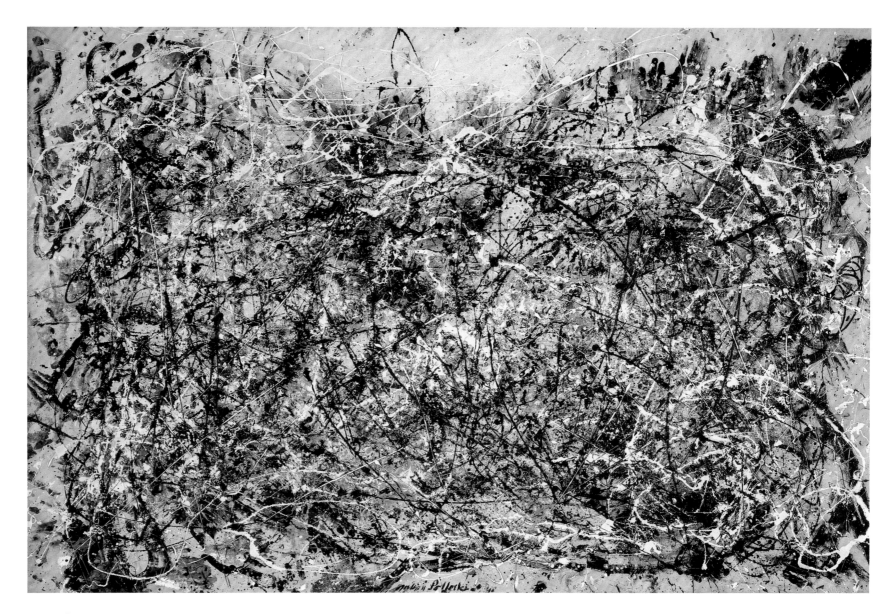

43 **Number 1A, 1948** 1948
Oil and enamel on canvas
172.7 × 264.2 cm
The Museum of Modern Art, New
York. Purchase

left the realm of culture for the domain of the bestial, a precultural space of formlessness. On the floor, painting is not orientated to the erect body of the human observer but to the animal in the dirt. The handprints may thus become evidence of a return to all fours. When Pollock linked this method of painting to 'the method of the Indian sand painters of the West', he implicitly associated it with 'primitive' expression. If the vertical position represented conscious control and culture – Pollock tended to assess his paintings in the vertical position before placing them back on the floor for further work – the horizontal represented the unformed, the unconscious and the instinc-tive. In the separate acts of painting and assessment Pollock hovers between uncontrol and control, between nature and culture, between chaos and order, between unconscious (or more likely preconscious) and conscious. Sam Hunter, reviewing Pollock's 1949 exhibition in the *New York Times*, commented that the show 'reflects an advanced state of the disintegration of the modern painting', but he thought this might possibly be liberating. Berger took this a stage further. It did not simply represent the disintegration of painting but 'of our culture'. More recently, Yve-Alain Bois, taking his cue from Bataille, rephrases this as entropy, the unstoppable slide into disorder.

44 **One: Number 31, 1950**
1950
Oil and enamel paint on canvas
269.5 × 530.8 cm
The Museum of Modern Art, New York. Sidney and Harriet Janis Collection Fund (by exchange)

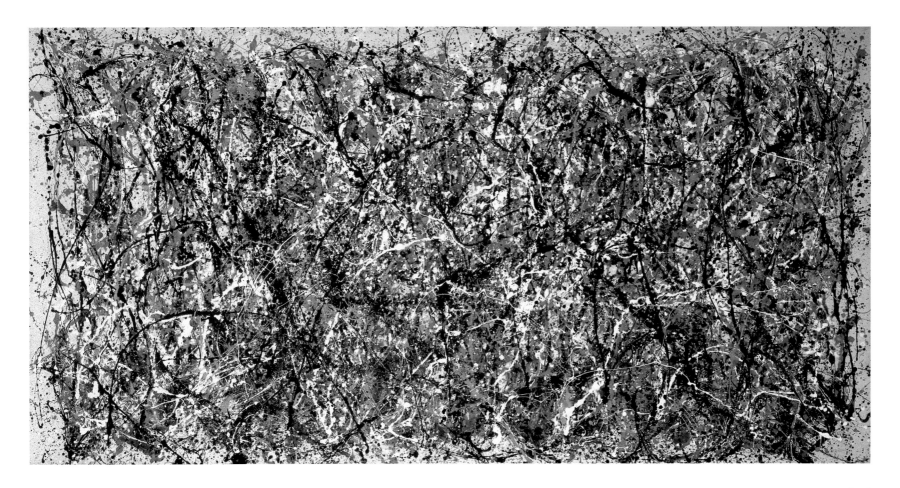

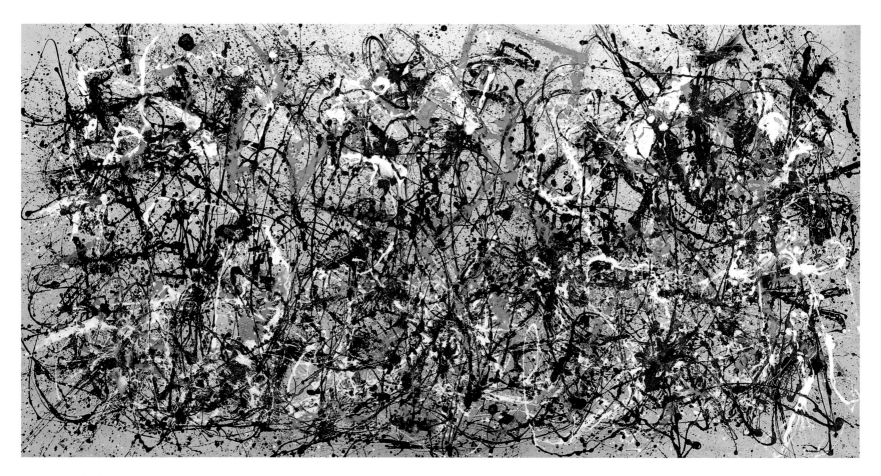

45 **Autumn Rhythm:**
Number 30, 1950 1950
Oil on canvas 266.7 × 525.8 cm
The Metropolitan Museum of Art,
New York. George A. Hearn Fund,
1957

46 **Lavender Mist:**
Number 1, 1950 1950
Oil, enamel and aluminium
paint on canvas 221 × 299.7 cm
National Gallery of Art, Washington,
DC, Ailsa Mellon Bruce Fund

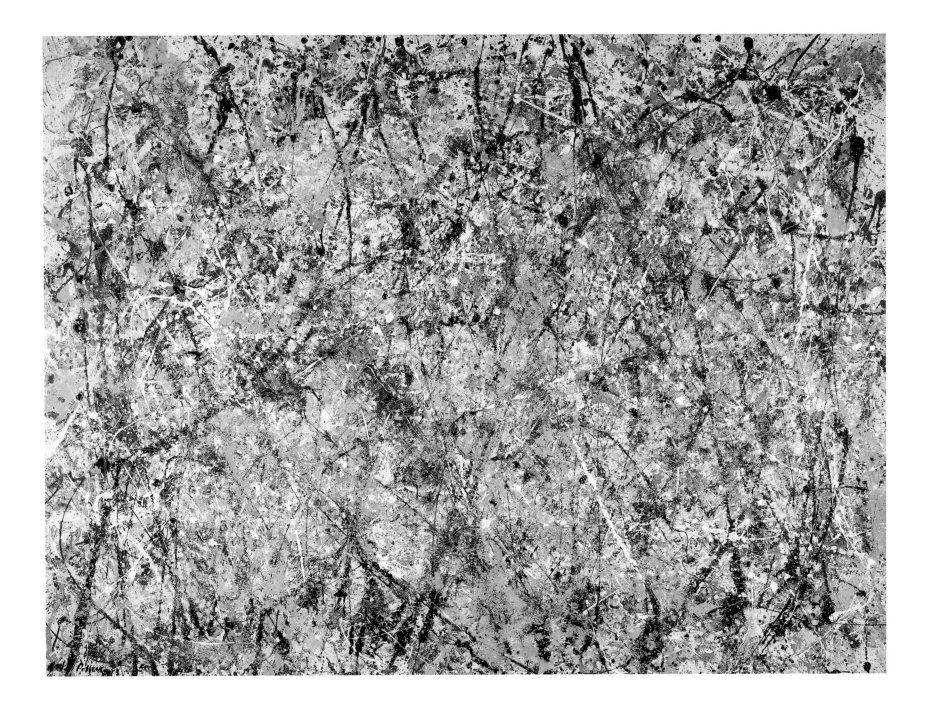

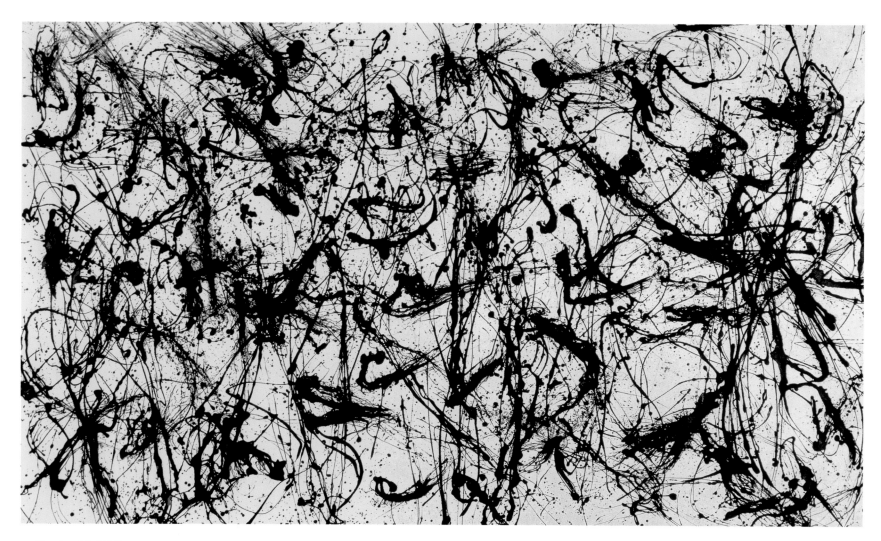

47 **Number 32, 1950** 1950
Enamel on canvas 269 × 457.5 cm
Kunstsammlung Nordrhein-
Westfalen, Düsseldorf

The disorder in Pollock's painting was characterised by many critics as freedom. In Harold Rosenberg's words: 'The gesture on the canvas was a gesture of liberation', although he interpreted this as a liberation from political, aesthetic and moral values, which it clearly was not. Meyer Schapiro took the opposite view, namely that automatism, or the accident, had a direct relationship to the context of production. In an article of 1957 published in *Artnews* he wrote: 'No other art today exhibits to that degree in the final result the presence of the individual, his spontaneity and the concreteness of his procedure. This art is deeply rooted, I believe, in the self and its realisation to the surrounding world. And the pathos of the reduction or fragility of the self within a culture that becomes increasingly organized through industry, economy and the state intensifies the desire of the artist to create forms that will manifest his liberty in this striking way.' While some critics disparaged Pollock for his seeming lack of control of the painting process, others, such as Clement Greenberg, who recognised the importance of Pollock early on, invented the myth that Pollock's dripped paintings were based on a Cubist structure in order to assert the opposite. Greenberg's own predilection was for an ordered, structured art and he was highly critical of the irrational. Others, like Robert

48 **Out of the Web:**
Number 7, 1949 1949
Oil and enamel on fibreboard
121.5 × 244 cm
Staatsgalerie Stuttgart

Goodnough, provided 'eyewitness' accounts of Pollock's 'slow and deliberate' process of painting. In England, whereas the critics in 1956 chastised Pollock for the apparent disorder in his paintings, in 1958 they reversed their view. As Lawrence Alloway put it in an article in *Art International* in 1958: 'the critics ... dropped the myth of Action [in other words randomness] and plumped for the myth of order.' The 1958 Whitechapel Art Gallery retrospective permitted the critics to detect consistency in Pollock's strategies and an underlying sense of structure. That structure had its basis in the strategy Pollock adopted for depicting the human figure in *Mural*, namely the use of linear motifs, sometimes with vestigial human reference, to confer some kind of order and to create some kind of space.

To make reference to the figure is not to depict it. Many of Pollock's paintings are as far from being figurative as it is possible to get. Krauss argues, convincingly, that Pollock's paintings of 1947–50, executed on the floor, are an index of horizontality; almost every mark which Pollock made could only be the result of the condition of horizontality and the draw of gravity. There are few run-offs of paint, the paint either sinks into the canvas or sits up on top. It puddles or pools. (It should be noted, however, that as Jim Coddington stated in a recent lecture, the green paint applied to the surface of *Lucifer* (1947) was applied when the painting was vertical, as evidenced by the run-offs. This is unlikely to be an isolated example.) Krauss argues that in painting on the floor Pollock attempts to get 'beneath the figure into the terain of formlessness'. The figure or the image is perceived by sight, which is a condition of verticality. Horizontality defeats the image because it is 'out of the field of vision ... below the body'. This theory denies the argument of gestalt psychologists that it is basic human instinct to form an image. This chapter has argued that however much Pollock may have wanted to move away from imaging, his gestures often contained a memory of the actions which create image, and those actions endowed the work, in its final stages, with a controlling structure. At times, as in *Autumn Rhythm* (fig.45), *Number 1, 1949* (fig.63), *Number 3, 1950* (fig.64) and *Phosphorescence* (fig.40), he appears to have achieved the formlessness which Krauss outlines, but at others his basic instinct overruled. Although the

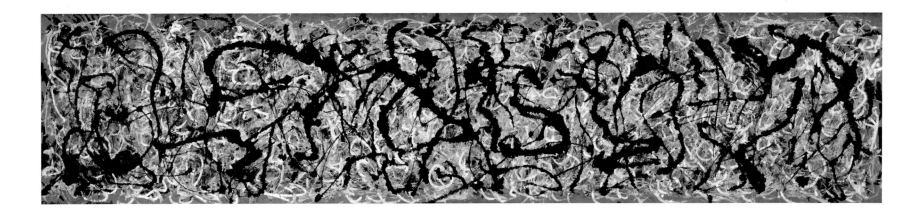

paintings exclude drawing, since they do not yield forms delineated by contours and do not describe images, yet at times the drawn line comes back into play suggesting that a dialogue between painting and drawing, or a struggle between them, is in process.

Three statements by or about Pollock appear to confirm the continued role of the figural reference. In 1947, in a magazine called *Possibilities*, Pollock published the following remark: 'I have no fears about making changes, destroying the image, etc., because the painting has a life of its own. I try to let it come through.' Although such a statement may be interpreted in a number of different ways, since it was made at the time he was covering up images of the human form, the word 'image' may imply figure. It might follow that what he is allowing to 'come through' is the 'image' rather than the 'life' of the painting. In an interview with B.H. Friedman, published in 1969, Lee Krasner stated: 'Many of [the paintings], many of the most abstract, began with more or less recognisable imagery – heads, parts of the body, fantastic creatures.' In 1956 Pollock declared: 'when you're painting out of your unconscious, figures are bound to emerge.' These three statements suggest that consciously or otherwise, Pollock was often compelled to make reference to the figure. The fact that during a period of struggle he returned to this familiar and perhaps comforting strategy – in *Unformed Figure* (1953), *Untitled (Scent)* which bears a vestigial trace of a de Kooning-like woman, and *Number 1, 1952* – after a period of overt figuration suggests that figuration was deeply ingrained. As Pollock stated in 1949 to Dorothy Sieberling, interviewing him for *Life* magazine: 'Recognizable images are always there in the end.'

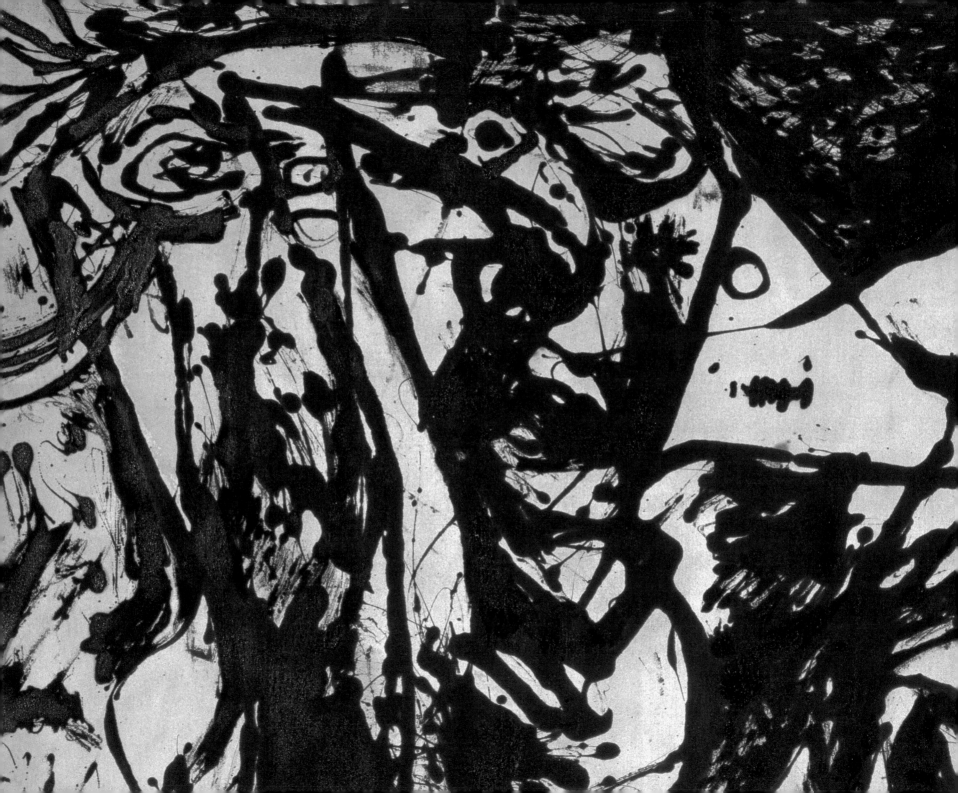

A Change of Direction?

Over the years there have been many reasons attributed to the so-called 'return of the figure' to Pollock's painting in 1951. Broadly they are as follows. After his successful exhibition at the Betty Parsons Gallery in 1950, where he showed *Number 32, 1950*, *Autumn Rhythm* and *One: Number 31, 1950*, reckoned later to be the peak of his dripped style, Pollock entered a state of depression. He was living temporarily in New York, away from his home on Long Island, and had returned to the bottle. The doctor who had been treating him for alcoholism, Edwin Heller, had recently died. If the mural-sized drip paintings represented the apogee of the drip style they seemed to some people to be leading nowhere. 'After the '50 show, what do you do next?' Krasner said to B.H. Friedman. 'He couldn't have gone further doing the same thing.' A number of critics felt that Pollock had reached an impasse and he was sensitive to such criticism. James Fitzsimmons was aware of this when, writing in *Art Digest* in December 1951 at the time of the first showing of the black paintings known as pourings, he remarked: 'It would seem that Pollock has confounded those who insisted he was up a blind alley.' Howard Devree echoed these sentiments when he wrote in the *New York Times* that Pollock seemed 'to be getting away from what threatened to be a dead end.'

Pollock had also been worried by the view that his paintings demonstrated facility but no skill. Writing to Alfonso Ossorio, his neighbour and friend, who was also a collector of his work, he stated that the black paintings of 1951 would disturb 'the kids who think it simple to splash a Pollock out'. Some critics had described Pollock's drip paintings as decorative, about the most pejorative term that could be applied to them. Working on the scale of the mural Pollock had run the risk that his work would be regarded as interior decoration. Walking into the Betty Parsons Gallery in 1950, the visitor saw *One: Number 31, 1950*, *Number 32, 1950* and *Autumn Rhythm* stretched from floor to ceiling as though congruent with the wall. In the case of *Autumn Rhythm* and *One: Number 31, 1950* they may simply have been stapled to the wall and were thus in the same plane. They could be read, in effect, as decorated walls. By contrast, the other, smaller paintings in the show clearly retained their presence as objects. These smaller paintings emphasised the outsize of the larger works and their nature as something different from the norm of 'easel' painting.

As early as 1943 Greenberg, in a discussion of *Guardians of the Secret* and *Male and Female*, remarked that they 'zigzag between the intensity of the easel picture and the blandness of the mural'. In 1948, in *Partisan Review*, he observed that the 'all-over' picture 'comes very close to decoration – to the kind seen in wallpaper patterns that can be repeated indefinitely'. Greenberg had encouraged Pollock to take painting beyond the easel to the mural but felt that in the black pourings Pollock drew back from this mission. Pollock had been on the look-out for mural commissions but with one exception they had not been forthcoming. In returning to a more overt depiction of the figure, was Pollock pulling back from the brink of decorativeness, or blandness, and reasserting his skill as a draughtsman-painter?

All this adds up to a picture of depression and uncertainty, a lack of confidence and a willingness to be influenced by external views. Some commentators suggest that this was why Pollock began to paint exclusively in black. Perhaps the most unsustainable of all motivations attributed to the exclusive use of black was that Pollock sought to give visual expression to his birth trauma. According to his mother's account, Pollock was 'born black as a stove' as a result of being choked by the umbilical cord. Equally conjectural is the theory that the use of black denotes mourning for Pollock's loss of sobriety following the completion of Namuth's film. These theories should be dismissed as no more than psychobabble.

Other external imperatives are also often invoked. In March 1950 Samuel Kootz mounted an exhibition in his gallery titled *Black or White: Paintings by European and American Artists*, which did not include Pollock but which comprised the work of William Baziotes, Willem de Kooning, Adolph Gottlieb, Robert Motherwell, Mark Tobey, Jean Dubuffet and Joan Miró. Franz Kline's exhibition of black-and-white paintings at Charles Egan Gallery in October is also cited as a possible spur as is Motherwell's at the Kootz Gallery. Furthermore, de Kooning had made black-and-white paintings in 1948–50, although it is not certain that Pollock had seen them. Finally, Ossorio had given him a book of reproductions of Goya's black paintings. Pollock undoubtedly had a competitive instinct but it is far from certain

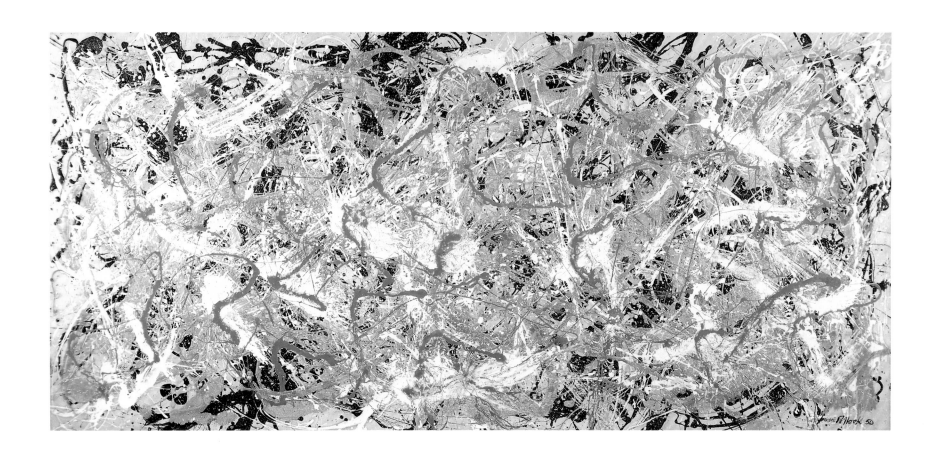

51 **Number 27, 1950** 1950
Oil on canvas 124.5 × 269.2 cm
Whitney Museum of American Art,
New York. Purchase

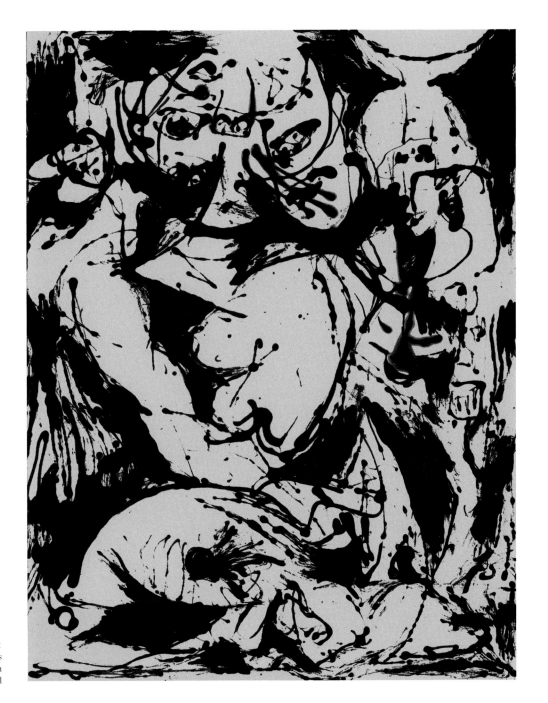

52 **Number 22, 1951** 1951
Oil and enamel on canvas
147.6 × 114.6 cm
Collection Denise and Andrew Saul

that he produced these paintings as a challenge to others who had worked with such limited means.

A theory has been suggested by E.A. Carmean (and dismissed by Rosalind Krauss) that Pollock's black pourings were connected to a project for stained glass windows he was devising with the architect Tony Smith. As Krauss observed, the fact that the paintings are not modular and do not conform in either size or format makes it hard to imagine them as studies for regularised architectural elements. Even the suggestion that Pollock's paintings were a response to and inspired by Matisse's black, linear paintings on tiles for the chapel at Vence looks specious. The latter's strict linearity and simplicity bear no relationship whatsoever to Pollock's paintings of 1951, which are highly complex compositions and puddled with paint. The problem with all these theories is that they suggest that Pollock could only react responsively rather than make decisions out of personal necessity.

Essentially all these arguments stress the difference between Pollock's dripped paintings of 1947–50 and the poured paintings of 1951, but this was not how everyone perceived them at the time. Greenberg asserted in *Partisan Review* in 1952 that Pollock's show at the Betty Parsons Gallery 'reveals a turn but not a sharp change of direction; there is a kind of relaxation, but the outcome is a newer and loftier triumph'. Lee Krasner, referring to the continuity in Pollock's work from the mid 1930s onwards, told Friedman: 'I see no sharp breaks, but rather a continuing development of the same themes and obsessions.'

T.J. Clark has written that Greenberg recognised that 'the figure – the place of the figure – was a question that Pollock's abstraction [of 1947–50] kept open.' The 'silhouettes' and 'ornamental motifs' which Greenberg detected in 1947 as integrated into the surface of the paintings were simply now more prominent. Clark argues, as indeed the previous chapter argues, that Pollock found it difficult to paint a purely abstract painting because ultimately a figure could always be seen within the skeins of paint. Rather than fight the impulse to exclude it, Clark maintains that he conceded to it. In 1948 Pollock had experimented with cut-out figures in a group of smaller works and in *Out of the Web* (fig.48), as though searching for a credible way to reintroduce overt figuration. The 1951 paintings can be seen

as a development one stage further on from these. Howard Devree recognised the continuity in Pollock's work when he reviewed the 1951 exhibition in the *New York Times*. Pollock was now 'turning the automatic emotional mazes', which Devree had observed in the dripped paintings, 'into nightmarish expressionist visions as of half-glimpsed and enmeshed witches' sabbath, black mass and unholy groups of doomsday aspect'. The web imagery was still present.

There is no way of knowing whether or not Pollock consciously retained references to the figure in the drip paintings but there is no reason to suggest that the emergence of the black pourings of 1951 was a concession or a defeat. This is to put a negative gloss on it. Rather, Pollock deliberately brought to the surface once again the elements he had previously driven underground, because the figure itself had again become of primary interest. He recognised the importance of this development in his letter to Ossorio dated 7 June 1951: 'I've had a period of drawing on canvas in black – with some of my early images coming thru'. Pepe Karmel has shown how a series of figure-like markings is buried beneath the surface of *Number 27, 1950* – indeed the black underlayer is still visible in places although it is impossible to make out any of the configurations. Nevertheless, from what is visible the thickness of the poured paint and the activity of the gestures indicate a resemblance to a number of the 1951 black paintings. Similarly, the existence of a figure on the right side of *Number 32, 1950* was indicated (see p.40). The fact that this painting is executed entirely in black suggests an obvious continuity in practice, even though the paintings of 1951 have a less pronounced linear emphasis. Moreover, in the drip paintings black had always been his preferred colour for drawing (see for example *Enchanted Forest*, *Cathedral* and *Reflection of the Big Dipper* (fig.41), all of 1947, and *Number 1A, 1948* and *Summertime* (figs.43 and 42) of 1948).

But what was the difference between these figurative paintings and previous references to the figure? In the dripped paintings the figural reference is either hidden beneath a web or is superimposed on top of it or is implied by the presence of the viewer. It is thus apart from but in a relationship to the main body of paint. In the black pourings, many of which were executed on unsized canvas, the figure and ground are fully

53 **Untitled 1951** 1951
Black and colour inks on Japanese
paper 62.8 × 99.1 cm
Collection Jane Lang Davis,
Medina, Washington

integrated into a single plane. There is in effect no distinction to be made between them. Black acts as both contour and mass. That much was hinted at in *Number 32, 1950*. But the difference between that painting and the works of the following year is that Pollock abandons his insistence on linear drips and goes for a combination of fine lines, puddles and pours. He had previously executed a series of works on Japanese paper in which the ink bled into and through the paper and seeing the effect of this must have stimulated him to attempt something similar on canvas. Indeed many of the marks he made in these drawings were translated in a relatively straightforward manner into the paintings (see for example the drawing *Untitled 1951* (OT 846) and *Number 5, 1951, Elegant Lady*). Some of the images are also correlative (see for example the drawing *Untitled 1951* (OT833) and *Number 18, 1951*). This might suggest that while some of the paintings were spontaneous, others were made bearing the memory of a previous image in mind (E.A. Carmean has asserted, not entirely convincingly, that Pollock made *Lavender Mist* with *Number 1A, 1948* in mind). This, then, is another difference in practice between the execution of the 1951 paintings and the dripped paintings of 1947–50. Fundamentally, drawing prevails over painting.

54 **Echo: Number 25, 1951**
1951
Enamel on canvas
233.4 × 218.4 cm
The Museum of Modern Art,
New York. Acquired through the
Lillie P. Bliss Bequest and the
Mr and Mrs David Rockefeller Fund

55 **Number 11, 1951** 1951
Enamel on canvas 146 × 352 cm
Private Collection

An affinity is often suggested between the 1951 paintings and those of the early 1940s and indeed the subject matter, as Pollock himself remarked, was similar. Totems, nudes and demonic figures re-emerge, but whereas in the earlier period the imagery was somehow overburdened and hard-won, the paintings of 1951 are exuberant, sometimes lyrical, sometimes infernal but rarely overwrought. There is a lightness and openness to *Echo: Number 25, 1951* and a subterranean or submarine feel to *Number 11, 1951*. Some of these paintings can be read in multiple ways. While *Number 11, 1951* appears to be a kind of land or seascape, when viewed vertically it becomes a standing female nude, perhaps pregnant and therefore a reference back to Picasso's *Girl Before a Mirror* (fig.6). *Number 14, 1951*, which Greenberg described as 'high classical art', may resemble one or two reclining figures but, when viewed vertically it becomes two

totems similar in format to *Two* (c.1945). If *Number 11, 1951* makes reference to Picasso's *Girl Before a Mirror*, then *Number 14, 1951* (fig.56) may allude to his *Girls on the Banks of the Seine (After Courbet)* of 1950, the composition having been reversed. Krauss correctly dismissed Carmean's suggestion that *Number 14, 1951* was a copy of Picasso's 1930 *Crucifixion*, but her refusal to accept that Pollock might have memorised a particular image is too emphatic. While *Number 14* is unrelated to Picasso's *Crucifixion*, since the iconographic links are very weak, the idea that he might have had an image in mind when making one of the paintings in 1951 is not so far-fetched. As has been noted above, on occasions he carried a memory of elements or entire compositions of his own drawings. Furthermore, in works of five to ten years earlier he showed an obsessive interest in Picasso. It is unlikely that he shed this interest entire-

56 **Number 14, 1951** 1951
Enamel on canvas
146.4 × 269.2 cm
Tate Gallery

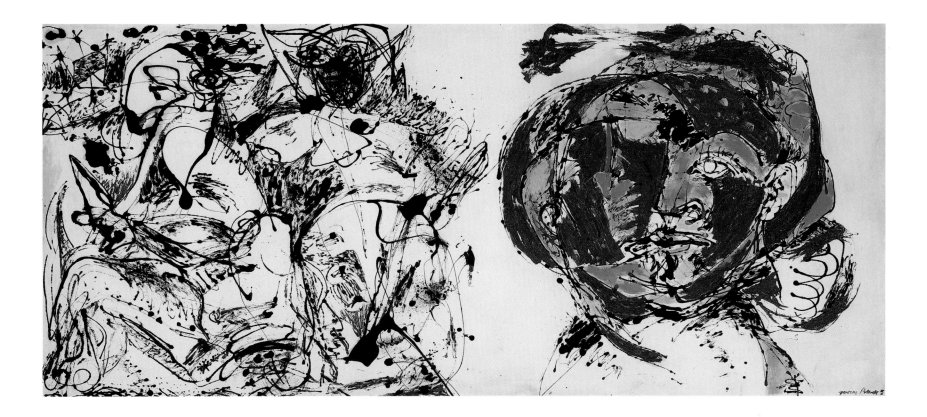

57 Portrait and a Dream
1953
Oil on canvas 148.6 × 342.2 cm
Dallas Museum of Art. Gift of Mr
and Mrs Algur H. Meadows and the
Meadows Foundation, Incorporated

ly even if his art had moved on from overt homage. It would be perfectly possible for Pollock, consciously or unconsciously, to adopt a form from Picasso which becomes filtered through memory, technical demands and artistic intention. The issue of control is not at stake. By 1951 Pollock was fully in control of his means and could delineate form with great proficiency by dripping and pouring. Moreover his frequent use of basting syringes increased the degree of control. To work from the basis of a remembered image is not to make an illustration but to use it as a point of jumping off.

The fact that Pollock's 1951 paintings are open to multiple readings is not surprising given the way in which they were made. Lee Krasner reported to Friedman: 'With the larger black-and-whites he'd either finish one and cut it off the roll of canvas, or cut it off in advance and then work on it. But with the smaller ones he'd often do several on a large strip of canvas and then cut that strip from the roll to make more working space and to study it. Sometimes he'd ask, "Should I cut it here? Should this be the bottom?" He'd have long sessions of cutting and editing, some of which I was in on, but the final decisions were always his. Working around the canvas – in the "arena" as he called it – there really was no absolute top or bottom. And leaving space between the paintings, there was no absolute "frame" the way there is working on pre-stretched canvas. Those were difficult sessions. His signing the canvas was even worse. I'd think everything was settled – tops, bottoms, margins – and then he'd have last minute thoughts and doubts.' Thus the look of a painting was determined at the last minute by Pollock's final choice of orientation, just as the look of a dripped work could be determined by a late addition of paint. Similarly,

58 Henri Matisse, *The Clown*, plate 1
(frontispiece) from *Jazz* 1947
42.2 × 65.1 cm
Museum of Modern Art, New York,
The Louis E. Stern Collection

59 Henri Matisse, *Composition with
Standing Nude and Black Fern* 1948
Oil on canvas 105 × 75 cm
Musée nationale d'art moderne, Centre
Georges Pompidou, Paris

60 **Untitled (Cut-out)** *c.*1948–50
Oil, enamel, aluminium paint and
mixed media on cardboard and canvas
77.3 × 57 cm
Ohara Museum of Art, Kurashiki, Japan

it could be determined by whether or not he separated two images by cutting between them.

If the influence of Picasso continued to be pervasive it is perhaps more surprising that Pollock might also have turned to Matisse to help him find a way forward, but it was not the Chapel of the Rosary that inspired him, as has been suggested. If Pollock's cut-out works of 1948 established a new way of dealing with the figure there seems to be no immediately internal spur for adopting this solution, other than perhaps the need to treat a clogged surface rather radically or a feeling that there was a need to make the figurative reference more explicit. If it were the case that he was already looking for the figure to re-emerge in 1948 then he may have been casting around for other models. One possible model was to be found in Matisse's *Jazz* (fig.58), which was published in 1947 and shown in New York in January 1948. There is a striking similarity between *Untitled (Cut-Out)* (fig.60), *Untitled (Cut-Out Figure)* and the frontispiece of *Jazz*, where a white figure with cut-off arms is set against a black ground. The first of the two Pollocks shows the figure as a white cut-out, a piercing of the canvas, echoing an illusion set up by Matisse's image; in the second work Pollock applied the figure he had sliced out of the first to a black ground, again echoing Matisse.

Krasner had earlier brought Pollock to an awareness of Matisse but by 1951 he was in the forefront of Pollock's mind. In an undated letter to Ossorio written towards the end of January 1951 he asked Ossorio, unprompted, whether or not he had visited the Matisse Chapel. The chapel project had been much talked about in New York and indeed Matisse's show at the Pierre Matisse Gallery had been a great success in 1949, as had the large retrospective held in Philadelphia in the preceding year. Greenberg, who was still close to Pollock at that point, stated in a letter to the *Nation* on 31 January 1948 that 'Matisse

[is] the greatest painter of the day' and in *Partisan Review* two months later he accorded Matisse the status of 'the greatest master of the twentieth century'. If Pollock did not see the Philadelphia show he was unlikely to have missed the Pierre Matisse exhibition and there he would have seen a series of large drawings of 1947–8, executed on white paper using black ink applied by brush (fig.59). In these drawings Matisse floods the sheet in a series of flowing, thick lines and masses. There is a continuity between figure and ground, as in Pollock's 1951 paintings, and the white of the paper is an active element of the composition, like Pollock's bare canvas. Moreover, Matisse, known as a colourist, could be seen by Pollock to be renouncing colour in these drawings. Indeed in Matisse's view black was a colour, more of light than of darkness. In combination with the white of the paper it generated light. So at the very moment when Matisse was embarking on an engagement with pure colour in the paper cut-outs, he also stepped back into black. Matisse remained in the headlines until at least 1952 thanks to a retrospective exhibition of his work at the Museum of Modern Art that year and the simultaneous publication of Alfred Barr's extensive monograph *Matisse, his Art and his Public*. It is not surprising, then, to find that Pollock's *Easter and the Totem* (fig.68) should reflect the structure and theme of Matisse's *Bathers by a River* (1916) and the colour scheme of *The Moroccans* (1915–16), both of which were included in the Museum of Modern Art's show.

Pollock's interest in Matisse was not as sustained as his passion for Picasso but it is possible that he had an impact on his method of painting. It is not proposed that the sight of works by Matisse led Pollock to change tack in 1951. There are too many internal motivations for this to be credible, but Matisse's example may certainly have helped him to find a technical solution to the problem of how to paint the figure.

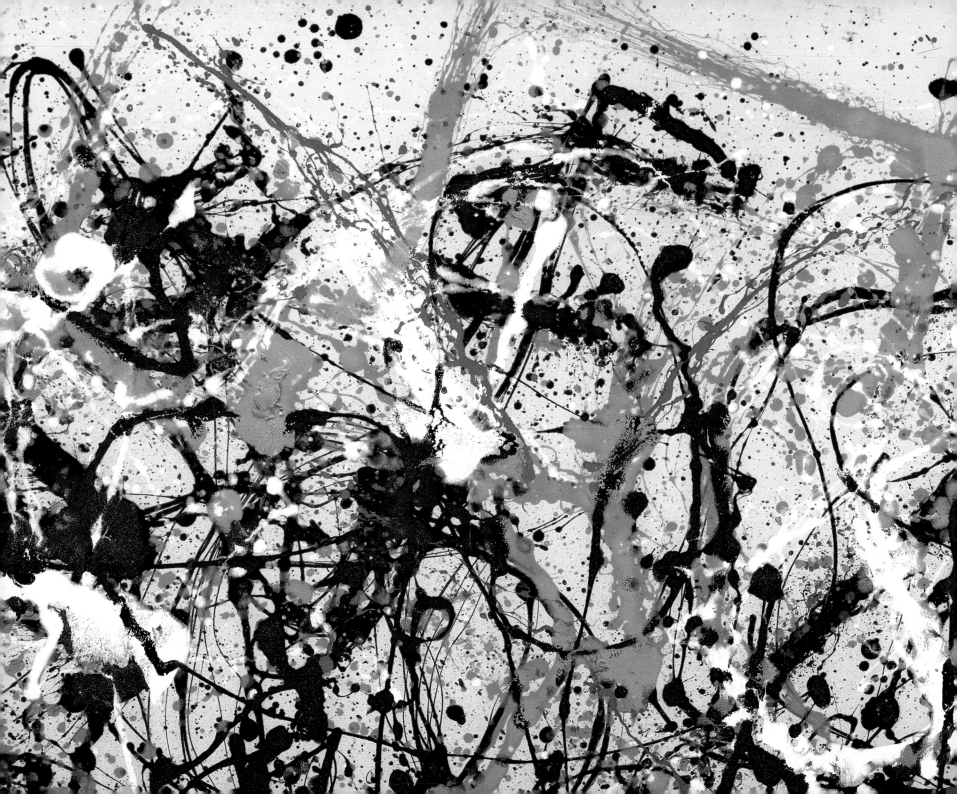

The Politics of Gender

The politics of the presentation of Jackson Pollock is by a now a familiar discussion within Pollock studies. With great justification articles have been devoted to the masculine image he and other Abstract Expressionists projected. Pollock's reputation was created as much by the photographs taken of him by Hans Namuth, Arnold Newman and Rudolf Burckhardt as it was by the evidence of the paintings. These photographs, allied with the belligerent and 'male' language employed by the critics to describe both him and his art, did much to create the reputation of the artist-hero, to turn him into a cultural icon, 'Il Presley della pittura', as one Italian critic put it.

Although Hedda Sterne was pictured among the group of artists known as the Irascibles, photographed by Nina Leen for *Life* magazine (published 15 January 1951), the work of women Abstract Expressionists has largely been ignored. Sterne, pictured standing on a table, considerably higher than the other artists and thus apart from the group, has been written out of history, while Lee Krasner and Grace Hartigan, two other first

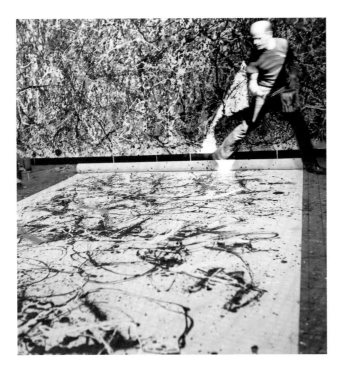

left **Autumn Rhythm: Number 30, 1950** 1950 (detail of fig.45)

right 61 Pollock at work on *Autumn Rhythm* 1950 Photograph: Hans Namuth © Hans Namuth Ltd

generation Abstract Expressionists, have never achieved the acclaim accorded to their male contemporaries. In the predominantly male climate Krasner shortened her name from Lenore to Lee, while Hartigan adopted the name George (after George Sand) for a while in the early 1950s. Once the tactic was adopted to characterise American abstraction as virile and violent, in contrast to the suave sophistication of the School of Paris, it became unfruitful for such critics as Clement Greenberg to promote the work of women artists.

When Greenberg first wrote about Pollock for a British audience, in *Horizon* in 1948, he used the following terms to characterise his work: 'Gothic, morbid and extreme' and 'violence, exasperation and stridency'. In 1945, in the *Nation*, he had described it as 'ugly', qualifying this judgement by saying that 'all profoundly original art looks ugly at first', a sentiment he repeated the following year. Pollock, according to his champion, was creating 'genuinely violent and extravagant art'. Greenberg constructed a view that American art was rough and brutal in contrast to French art and he spoke out in these terms in a review in which he directly compared Pollock with Dubuffet: 'He [Pollock] is American and rougher and more brutal, but he is also completer. In any case he is certainly less conservative, less of an easel painter in the traditional sense than Dubuffet ... Pollock points a way beyond the easel, beyond the mobile, framed picture to the mural, perhaps – or perhaps not. I cannot tell.' Greenberg infers that Pollock's painting is radical and tough, Dubuffet's conservative and effeminate. Dubuffet's is confined to the easel, to the scale of the domestic; Pollock's is expanding to the mural, into the public domain. Scale, as T.J. Clark has indicated, was an 'operator of sexual difference'. Of course, as Serge Guilbaut has pointed out, the use of such vocabulary was intended to establish the power of the New York School over the School of Paris in the fight for cultural leadership and Greenberg played an important role in this battle. American art had for so long been seen to be following Paris that if it was to assert itself as a viable national school it had to define itself by its difference. It became the norm among critics to see Abstract Expressionists, and Pollock in particular, as exemplars of masculinity, painters of raw power rather than delicate sophistication. Greenberg was by no means the only critic

62 Jackson Pollock in 1928
Archives of American Art,
Smithsonian Institution,
Washington, DC

sive spirit of revolt' of the Abstract Expressionists and alluded to Pollock's 'bursting masculinity'. He pictured Pollock engaged in a 'violent combat' in the 'arena of conflict and strife', making obvious reference to Harold Rosenberg's existentialist notion of the canvas as an arena for action. Bestiality was also invoked, not least perhaps because Pollock was seen to prowl around his canvas like an animal stalking its prey. This construction was confirmed by Hans Namuth's and Arnold Newman's photographs. Pollock was caught flinging paint and moving around his canvases with the agility of an athlete or the concentration of tiger (fig.61). Open-mouthed shots suggested that it took the strength and effort of a Titan. Alternatively he was photographed sitting in front of his overwhelming canvases which threaten to engulf him, or sitting outside (fig.1), or in the studio, cigarette dangling from his lips, facing directly into the camera in a pensive pose, or scowling in front of his Model-A Ford. These images are part of the 'heroic' construction of Jackson Pollock and his work has now become inseparable from them. They have rightly been compared to photographs of Marlon Brando, James Dean and other Hollywood actors whose brooding masculinity, virility and rebelliousness were so popular with cinema audiences. As Leja has pointed out, even Pollock's habit of talking in clipped statements echoes the characteristics of the heroes of *film noir*. The photographs of Pollock lend themselves to sexual interpretation, as does his process of painting.

Masculinity and power were also inferred by allusion to his origins. Although he stayed there for a very short time (less than a year), it was always stressed that Pollock was born in Cody, Wyoming, the town which Americans would recognise as having been named after William (Buffalo Bill) Cody. As Kirk Varnedoe has indicated, Pollock's first exhibition announcement for his show at Art of This Century was headlined 'Young Man from Wyoming', as though this was a particularly pertinent fact. But his 'cowboy' origins, fictional though they were, were taken up 'officially' by the promoters of his art as well as by the critics. For example Alfred Barr, in his text for the American pavilion at the Venice Biennale in 1950, wrote that Pollock 'was born in the Far West in a city named after Buffalo Bill' as though this conferred some meaning upon his work. From this it was a short step for Homer Cahill to take, in the catalogue

to comment in these terms. Writing during the war or shortly thereafter, it was as though Pollock was part of the war effort to protect democracy and culture from fascism and repression. Even in the late 1950s, Lawrence Alloway likened Pollock's paintings to 'a saturation bombing raid' and Michel Tapié talked of having launched 'a bomb' onto the Parisian art world. The idea that Pollock's painting expressed 'a radical new sense of freedom' enhanced the impression that he was on the side of the liberators. It is ironic that Pollock, reprieved from war service on medical grounds, should have been imaged in this way.

Virility and aggression were characteristics commonly ascribed to Pollock's painting. Robert Goodnough talked of Pollock's 'violent ways of expression' and affirmed that it required 'strength' to paint like Pollock. Sam Hunter, in his introduction to the touring retrospective of 1957–8, referred to the 'aggres-

introduction to *Modern Art in the United States*, when he wrote that Pollock's '*Number 1* [fig.43] gives mysterious hints of depth in the areas lassoed by the plunging gallop of line'. Pollock had also been photographed as a young man in the 1920s wearing cowboy clothes and the fact that he was seen to be wearing jeans in most of the photographs taken of him by Namuth and Newman confirmed the tough-guy image. In an interview with the *New Yorker* in 1950 Pollock elaborated on this image: 'I grew up in the country. Real country – Wyoming, Arizona, northern and southern California. I was born in Wyoming. My father had a farm near Cody. By the time I was fourteen, I was milking a dozen cows twice a day.' It was probably not surprising to the audience, therefore, when almost the first words Pollock uttered on the soundtrack to Namuth's film were: 'I was born in Cody, Wyoming.' He fully participated in the construction of the cowboy myth.

How did the construction of the myth of masculinity serve Pollock's purpose? While he may have approved of Greenberg's agenda, the supremacy of the New York School over the School of Paris may not have been foremost in his mind in constructing his own image. Pollock was competitive by nature – witness his attitude towards Picasso – but the masculine identity must have served some purpose other than to further the American cause.

There can be no doubt but that Pollock, with the help of Krasner, participated willingly in what has been called the 'masquerade' of masculinity. None of the photographs were taken surreptitiously. With the exception of Namuth's action photographs, until 1950 no photographs of Pollock had been taken which were not specifically posed and therefore subject to Pollock's control. He had the option not to co-operate with the celebrated article in *Life* magazine headlined 'Is he the greatest living painter in the United States?' He had hesitated about doing so, but ultimately, he and Krasner were so delighted with it that she handed out copies at the opening of his next exhibition at Betty Parsons's Gallery. Above the headline, Pollock was seen standing casually in front of *Summertime*, arms folded and legs crossed, dressed in black denim jeans and jacket, with a cigarette in mouth. The caption reports that he was standing 'moodily'. Pollock's stance could not but be seen as masculine, provocative and insolent, protecting the painting from frontal attack and challenging those who might not think he was the greatest living painter. It was following the appearance of this article and seeing the crowd of collectors at Pollock's opening that de Kooning commented that 'Jackson broke the ice'.

There was always, however, an essential ambiguity to Pollock's persona. As a young man in California, although he was not averse to getting into fights, he adopted the look of a delicate aesthete, paying attention to his appearance, sweeping back his long flowing hair to reveal full, slightly effeminate features. He even took to calling himself Hugo, a name with a European ring. Once in New York his image was to change under the care of Thomas Hart Benton, whose low esteem of women was well known and whose insistently macho antics clearly rubbed off on Pollock. Benton blamed the tightening grip of abstraction on the weakness of effeminate men, especially homosexuals, and his macho behaviour was a deliberate counter to this. Although Pollock was already well into drinking to excess, Benton's example was clearly an encouragement to continue in this way. As Stephen Spender commented, it was almost the norm for creative males in America to be alcohol dependent. The fact that Pollock was unable to sustain or enter into any meaningful relationship with a woman until he met Lee Krasner suggests that the masculinity may have been something of a masquerade. Nothing hides shyness or effeminacy quite so much as a macho image.

Almost everyone who knew Pollock testified to both the violent, masculine side of him, which generally manifested itself when he was drunk, and the gentle, effeminate side shown for example in his love for animals and children. Given his interest in Jung, or at least Jungian therapy, he would have been aware of the idea that the creative aspect was associated with the feminine principle, the anima. As Leja suggests, perhaps the very notion of exploring the unconscious implies the exploration of the feminine within the male. His intent – 'I want to express my feelings' – does not have a masculine ring. But in the context of the masculine image adopted by the New York School artists and the masculine climate created by Greenberg's assertive vocabulary, which implied that Parisian art, by its very sophistication, was effeminate, Pollock had to play the game to succeed. The more so since there was a danger that Pollock's work

from 1947–50 could be considered effeminate. Here is Greenberg again in January 1948 in the *Nation* describing Pollock's dripped paintings of 1947: 'the use of aluminium runs the picture startlingly close to prettiness'. 'I already hear: "wallpaper patterns"', he lamented. This was three years after he had called Pollock's earlier works 'ugly', an essentially male term. In the same year, in *Partisan Review*, he observed that the 'all-over' picture 'comes very close to decoration – to the kind seen in wallpaper patterns that can be repeated indefinitely'. Greenberg was disturbed by the decorative quality of some of Pollock's paintings, by their prettiness, by his iridescent colour combinations which, at times, come close to kitsch. Decoration was domestic, the province of the home and the homemaker, thus the feminine. Pollock shunned the domestic. He was almost never photographed in a domestic environment but always in the studio, outdoors or in a gallery. Decoration is compliant. Abstract Expressionists assumed the posture of non-compliance. If there were one thing they worried about it was that their work would be considered decorative. William Gaunt, in an article in *The Times* in 1958 prompted by the Pollock retrospective at the Whitechapel Art Gallery, defined a decorative painting as one that 'adapts itself to, rather than creates the impression of a break in, the wall surface'. He suggested that 'consideration' in such works must be given to 'harmony of surface'. From this it could be extrapolated that decorative painting bends to the will of architecture and does not assert itself. It is stereotypically feminine.

Cecil Beaton's photographs of fashion models posing in front of Pollock's paintings, published in *Vogue* in 1951, are now celebrated documents which art historians have employed to prove a range of theories about Pollock and the socialisation of his art. Clark has suggested that the wildness, the primitive impulse, the vulgar, uncharted territory or 'uncolonized areas of experience' represented by the dripped paintings were colonised by the bourgeoisie through the act of glamorisation. But what has been characterised by Clark as 'vulgarity' could also be effeminacy. The fact that Cecil Beaton used Pollock's exhibition of 1950 drip paintings as backdrops for fashion shoots demonstrates that Beaton saw that they were suitable for the display of extreme femininity, the fashion model in the latest dress, either because they were male counterfoils or because they were female complements. The latter seems the more likely. Beaton picked out *Autumn Rhythm* as the background for a model wearing a black dress cut by a contrasting pink sash with a large bow in the shape of a rose (fig.65). The pink sash complements the tones in the painting, immediately feminising it. The sharp diagonal thrust of her dress replicates the directional nature of the drips and pours and the position of her left arm reflects the brown right-angled mark above her (see p.68). Another photograph shows a different model, bearing an open fan, posing before *Number 1, 1950*. The fan is a feminine accessory. Its ribs dart off in different directions, echoing the movement of the skeins of paint. Yet another photograph depicts a model in front of *Number 28, 1950* wearing a chiffon scarf whose rhythmic movement echoes the gestures of Pollock's painting. If Beaton had not himself noticed the innate effeminacy of Pollock's painting nevertheless these pictures surely help to gender them. They have thus been colonised twice over. Even the web imagery was susceptible to allusion to the feminine; Parker Tyler referred to Ariadne when describing Pollock's paintings.

If Greenberg noticed the risk that these paintings might be considered effeminate then he had all the more reason to be vigorous in characterising them as manifestations of the masculine. Without Pollock his cause might be lost. Pollock too, must have been aware of the danger. Rather than being decorative, Pollock claimed that his paintings were expressions of the age of 'the airplane, the atom bomb, the radio', all expressions of masculinity or of technologies colonised by the male. But in 1947 he stated that 'When I am *in* my painting, I'm not aware of what I'm doing', and that 'there is pure harmony, an easy give and take' in the painting process. These explanations suggest compliance with the painting. By 1950, when he was sensitive to criticism that his paintings were the product of accident, he modified his position and emphasised his degree of control: 'I do have a general notion of what I'm about and what the results will be.' 'It seems possible to control the flow of paint, to a great extent, and I don't use ... the accident.' By now he wanted publicly to assert his control over the painting, a stereotypically male characteristic. In spite of the overwhelming masculine image projected through critical writing and photography,

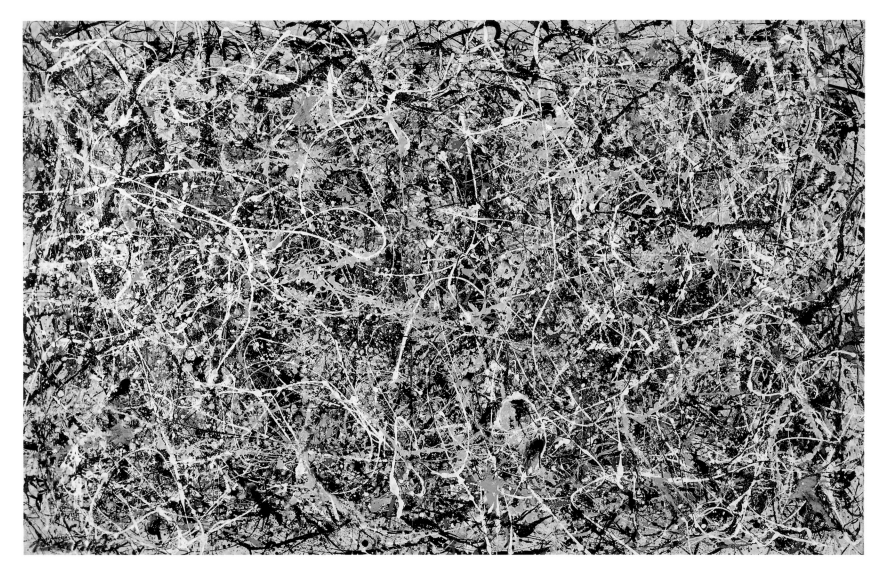

63 **Number 1, 1949** 1949
Enamel and aluminium paint on
canvas 160 × 259 cm
Museum of Contemporary Art,
Los Angeles. The Rita and Taft
Schreiber Collection. Given in
loving memory of her husband,
Taft Schreiber. by Rita Schreiber

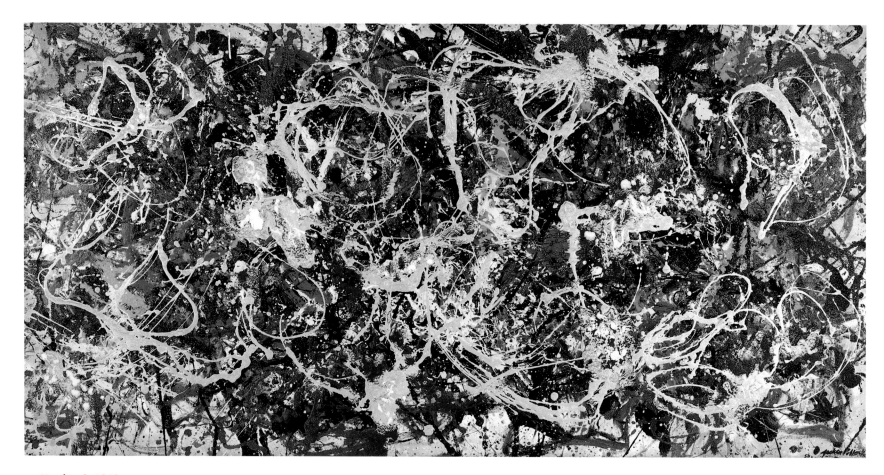

64 **Number 3, 1950** 1950
Oil, enamel and aluminium paint
on fibreboard 121.9 × 243.8 cm
Private Collection

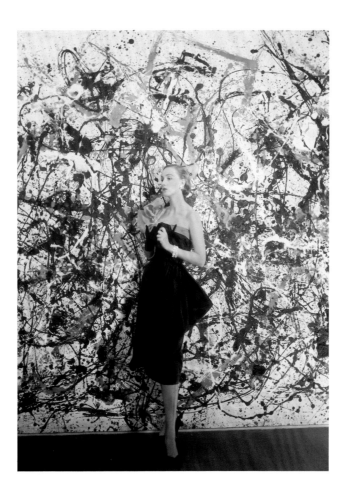

65 Cecil Beaton's photograph of a model in front of *Autumn Rhythm*, *Vogue*, 1 March 1951
Courtesy of Sotheby's London

Pollock may have had a continuing sense of insecurity about whether it would be regarded as effeminate. This might explain why he returned in 1951 to painting images reeking of masculinity; female nudes and scenes of violence, the kinds of images in the paintings which Greenberg had originally characterised as 'ugly', 'violent' and 'extreme'. Their facture, however, was entirely different.

In Pollock's first catalogue, James Johnson Sweeney wrote: 'Pollock's talent is volcanic. It has fire ... It is lavish, explosive, untidy.' The orgasmic qualities of this description were perhaps not fortuitous. In an earlier chapter, Pollock's relationship to Picasso was described as Oedipal. If this was the case the paintings were the Jocasta of the relationship. Given that Pollock dripped paint onto canvases spread out horizontally on the floor and that his paints were essentially liquid, Krauss compares the painting process with the act of male urination, in Freudian terms the extinguishing of the fire, the destruction of culture, while Varnedoe likens it to sexual intercourse. For them painting becomes an act of sublimation. In this context the fact that Pollock rarely allowed Krasner into the studio while he was painting, or 'inseminating', the canvas takes on added significance. Reuben Kadish has written that Pollock's 'work was a private experience which is why he would not tolerate having Lee in the studio'. Naifeh and Smith describe how Pollock asserted himself through public acts of urination and bedwetting. For them these acts were manifestations of destructiveness and masculinity, echoed in the act of dripping paint, where Pollock 'found the potency that had eluded him in real life'. Indeed, they intimate that Pollock had homosexual drives.

It is too speculative to conclude that Pollock's inability or unwillingness to form a close relationship with a woman of his age before Krasner, his lack of children, his difficult relationship with his mother and his excessively male image indicate a latent bisexuality. Undoubtedly the politics of masculinity were employed by others to promote the strength of the New York School. Furthermore, male dominance was a normal pattern of behaviour in the 1950s, especially among that generation of painters, but Pollock himself does seem to have encouraged the use of an excessively masculine image to camouflage femininity, of his painting at the very least.

[75]

No Way Out

After his 1951 show Pollock did not renew his contract with Betty Parsons. Dissatisfied with sales, unhappy with her stable of artists, which included many minor ones, threatened possibly by her lesbianism, he tried to secure a contract with one of the more important dealers in New York. His first target was Pierre Matisse but he failed to arouse his interest, Matisse having received a shrug of the shoulders from Marcel Duchamp on consulting him on Pollock's merits as an artist. Most dealers, knowing Pollock's reputation as a violent drunkard, were afraid to touch him. Finally he was welcomed across the hall from Parsons at the gallery of Sidney Janis. Janis was really a last gasp. Although the 1951 show had enjoyed critical success Pollock was still perceived as high risk.

His work was included in an exhibition in Paris at Studio Paul Facchetti in March 1952, organised by Michel Tapié, a supporter of the European *informel* and COBRA. It was visited by Tristan Tzara, Joan Miró, Enrico Donati, Alexander Goetz, Camille Bryen, Pierre Soulages, Jacques Doucet, Pierre Tal-Coat, Jean Degottex, Karel Appel and Sam Francis among artists, and R.V. Gindertael, Michel Ragon, Edouard Jaguer, Marcel Jean, Michel Seuphor, Reyner Banham and Herta Wescher among writers as well as a number of important European collectors and Parisian gallery directors. It may have been a *succés d'estime* but it had little commercial success. Pollock's subsequent exhibitions at Janis became increasingly painful. As his alcoholism took a tighter grip, so his productivity declined and his creativity appeared to diminish. From 1952 onwards he struggled to find a direction and by and large returned to idioms that had served him well in the past. He seemed capable of little more than going through the motions. He sought safety and comfort in the familiar. He was marking time as well as perhaps searching for a way out of an impasse. By 1955 he had virtually stopped producing at all, so that Janis was forced to transform his exhibition that year into a retrospective.

In the final four years of his life Pollock was on a downward spiral at the very time that Krasner's own career was taking off. He reworked existing paintings, for example *Convergence: Number 10, 1952*, where a black pouring has been altered by the superimposition of dripped and spattered coloured paint, a style that he had left not so much in 1950 but rather in 1947 or 1948. Similarly, in *Number 1, 1952* a ground of paint squeezed directly from the tube is enlivened by a scrolling black line. In *Blue Poles* (fig.3) he once again made extensive use of aluminium paint and employed orange in the manner in which he had previously used black to bring the eye to the surface of the painting and to unite its disparate parts. Where this painting differs from earlier dripped works is in its orgiastic, riotous colour, its heavily clogged surface and its execution, in part at least, in the vertical position.

Suffering from a state of artist's block, or alcoholic paralysis, Pollock was encouraged to get started on *Blue Poles* by his friend, the architect Tony Smith, who had always wanted him to work on a large scale. But Pollock was in no state to achieve the control evident in such paintings as *Autumn Rhythm* or *One: Number 31, 1950*. Instead he resorted to the superimposition of the poles to rescue the work from disorder. According to Stephen Polcari, these poles are reminiscent of Thomas Hart Benton's diagrams illustrating horizontal space-construction. Whether or not this is the case, they refer obliquely to figures standing before a ground. Moreover, they recall the use of poles in the very early painting, *Unititled (Composition with Figures and Banners)* (c.1934–8), itself reminiscent of Velázquez's *The Surrender of Breda*. The scale and organisation of *Blue Poles* is redolent of baroque painting in its extreme painterliness, *mouvementé* surface, strong reliance on serpentine and diagonal thrusts, depth of space and opulent colour.

The paintings, and indeed the lack of paintings, in the final years stand as a testimony to illness and the struggle for life. While it would be speculative to assert that the force of Pollock's frustration and anger come through visibly in *Yellow Islands* (1952), where a painting which started out in the manner of a black pouring of 1951 has been 'destroyed' by dumping a quantity of black paint on the canvas while in the vertical position, nevertheless there appears to be a certain anarchy in such a gesture which is not found in previous paintings. The solace and safety of the familiar has been subverted by a swift and destructive gesture.

The figure played an increasingly prominent role in Pollock's final years. Not only is it found in *Portrait and a Dream*, painted in the idiom of the 1951 pourings, but also in the overtly figurative *Ritual* (1953), where Pollock combines the Picassoesque

White Light 1954
(detail of fig.66)

with the Beckmannesque in a composition which appears to hark back to *Birth* and to the impact of Orozco. In *Untitled (Scent)* the figure is buried beneath an incandescent surface in a manner reminiscent of *Full Fathom Five* and seems to offer a muted challenge to Pollock's contemporary rival de Kooning, whose depictions of women in the landscape were enjoying success. Neither this nor *White Light* (fig.66), in which Pollock returns to a method of applying paint he had employed in *Eyes in the Heat* (fig.37) and *Shimmering Substance*, show any real advance, but merely a reiteration with some modifications.

Only two paintings suggest a possible way forward in Pollock's final years: *The Deep* (fig.67) and *Easter and the Totem* (fig.68). In *The Deep*, where paint is applied predominantly by brush, Pollock evokes a deep space, often referred to poetically or speculatively as vaginal. He appears here to renounce the shallow space of the dripped works and the flatness that Greenberg insisted upon as a prerequisite of modernist painting. In striving for a painterly effect, however, Pollock labours the brushwork, and the white surface, so inflected by brushmarks and so thinly painted, remains unintentionally flat. Nevertheless, in this painting Pollock appears to have been looking for a new image, one which allowed him to escape the enveloping web and pass through the picture plane to a state of transcendence. In a recent lecture, Carol Mancusi-Ungaro has pointed out that an early state of this painting showed an affinity with the work of Clyfford Still but Pollock destroyed this work in the search for something more personal. It was a bid for freedom – from the tyranny of a signature style and the accusations of having reached an impasse. In *Easter and the Totem* Pollock plunders Matisse and allies him with Picasso, whose formulas were tried and trusted in earlier years, to produce a painting whose figuration is less heavily contoured and vulgar than in *Ritual*. The sensuousness of earlier dripped, all-over surfaces is translated into delicate brushwork within a clearly structured, hierarchical composition. Whether Pollock could have developed this further to challenge de Kooning as the major abstractly figurative painter of his generation will never be known. On 11 August 1956, after an evening of heavy drinking, Pollock drove into a tree and died instantly.

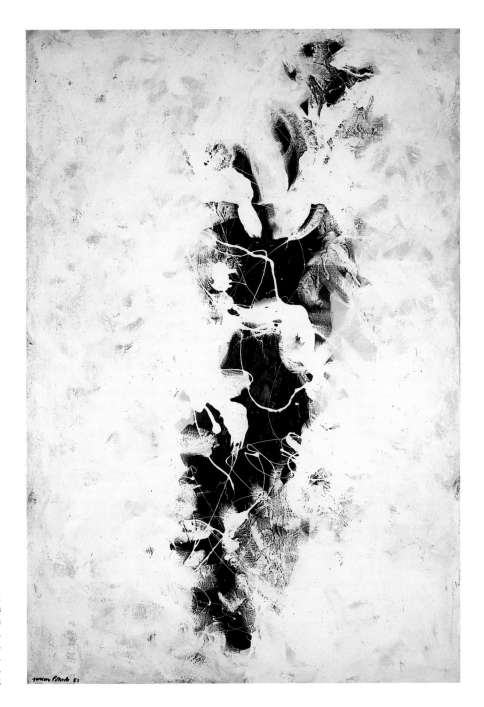

left 66 **White Light** 1954
Oil, enamel and aluminium paint
on canvas 122 × 96.9 cm
The Museum of Modern Art, New York.
The Sidney and Harriet Janis Collection

67 **The Deep** 1953
Oil and enamel on canvas
220.4 × 150.2 cm
Musée national d'art moderne,
Centre de Création Industrielle,
Centre Georges Pompidou, Paris.
Donated by The Menil Foundation,
Houston, 1975

68 **Easter and the Totem** 1953
Oil on canvas 208.6 × 147.3 cm
The Museum of Modern Art,
New York. Gift of Lee Krasner in
memory of Jackson Pollock

Select Bibliography

In writing this book I have made use of the scholarship of a number of people but none more so than Michael Leja whose recent contribution to the study of Pollock and Abstract Expressionism is particularly significant. I would like, therefore, to record my debt to him, while exonerating him from responsibility for any of the views I have expressed.

I list below a small number of the works on Pollock to which I have referred or which might be of interest to the general reader. For a general account of Pollock's life and work the texts by Kirk Varnedoe and Ellen Landau are the most complete. The most recent and exhaustive biography is by Steven Naifeh and Gregory White Smith.

Quotations in the first chapter from Robyn Denny and Bridget Riley are taken from interviews I conducted with them and those from Alan Davie are from an exchange of letters with him. The quotation from Herbert Read is taken from Anne Massey, *The Independent Group*, Manchester 1995. The quotation from Reuben Kadish in the penultimate chapter is also taken from an exchange of letters. References to the work of James Coddington and Carol Mancusi-Ungaro are to lectures given at the Jackson Pollock symposium held at the Museum of Modern Art, New York on 23 and 24 January 1999.

The abbreviation OT in the text refers to Francis V. O'Connor and Eugene V. Thaw's catalogue raisonné. Following their conventions, titles in parentheses are those which, while not given by Pollock, have become accepted through general usage. Descriptive titles assigned by O'Connor and Thaw appear in square brackets.

Yve-Alain Bois and Rosalind Krauss, *Formless: A User's Guide*, New York 1997

E.A. Carmean Jr, 'Jackson Pollock: Classic Paintings of 1950' in E.A. Carmean Jr and Eliza E. Rathbone with Thomas B. Hess, *American Art at Mid-Century: The Subjects of the Artist*, Washington 1978

E.A. Carmean Jr, 'The Church Project: Pollock's Passion Themes', *Art in America*, Summer 1982

T.J. Clark, 'Jackson Pollock's Abstraction' in Serge Guilbaut (ed.), *Reconstructing Modernism: Art in New York, Paris and Montreal 1945–1964*, Cambridge, Mass. and London 1990

T.J. Clark, 'In Defense of Abstract Expressionism', *October*, Summer 1994

Robert Goodnough, 'Pollock Paints a Picture', *Artnews*, May 1951

Donald Gordon, 'Pollock's "Bird", or How Jung Did Not Offer Much Help in Myth-Making', *Art in America*, October 1980

Clement Greenberg in John O'Brian (ed.), *Clement Greenberg: The Collected Essays and Criticism*, Chicago and London 1986

Serge Guilbaut, *How New York Stole the Idea of Modern Art*, (transl. by Arthur Goldhammer), Chicago and London 1983

Pepe Karmel: see Kirk Varnedoe

Rosalind Krauss, 'Contra Carmean: The Abstract Pollock', *Art in America*, Summer 1982

Rosalind Krauss, *The Optical Unconscious*, Cambridge, Mass. and London 1993

Rosalind Krauss, see Yve-Alain Bois

Ellen Landau, *Jackson Pollock*, London 1989

Elizabeth Langhorne, 'Jackson Pollock's "The Moon-Woman Cuts the Circle"', *Arts Magazine*, March 1979

Michael Leja, *Reframing Abstract Expressionism: Subjectivity and Painting in the 1940s*, New Haven and London 1993

Steven Naifeh and Gregory White Smith, *Jackson Pollock, an American Saga*, London 1989

Francis V. O'Connor and Eugene V. Thaw, *Jackson Pollock: A Catalogue Raisonné of Paintings, Drawings and Other Works*, New Haven and London 1978

Andrew Perchuk, 'Pollock and Postwar Masculinity' in Andrew Perchuk and Helaine Posner (eds.), *The Masculine Masquerade: Masculinity and Representation*, Cambridge Mass. and London 1995

Stephen Polcari, 'Jackson Pollock and Thomas Hart Benton', *Arts Magazine*, March 1979

William Rubin, 'Pollock as Jungian Illustrator: The Limits of Psychological Criticism', *Art in America*, November and December 1979

William Rubin, 'Jackson Pollock and the Modern Tradition', *Artforum*, February, March, April and May 1967

Parker Tyler, 'Jackson Pollock: The Infinite Labyrinth', *Magazine of Art*, March 1950

Kirk Varnedoe and Pepe Karmel, *Jackson Pollock*, exh. cat., Museum of Modern Art, New York 1998

Jonathan Weinberg, 'Pollock and Picasso: The Rivalry and the "Escape"', *Arts Magazine*, Summer 1987

Index

Copyright Credits

Photograph Credits